THE HUNGER ARTISTS

The Hunger Artists

Starving, Writing, and Imprisonment

Maud Ellmann

Harvard University Press
Cambridge, Massachusetts
1993

Copyright © 1993 by Maud Ellmann
All rights reserved
Printed in the United States of America
10 9 8 7 6 5 4 3 2 1

"Art thou the thing I wanted?" reprinted by permission of the publishers and the
Trustees of Amherst College from *The Poems of Emily Dickinson*, Thomas H.
Johnson, ed., Cambridge, Mass.: The Belknap Press of Harvard University Press,
Copyright © 1951, 1955, 1979, 1983 by the President and Fellows of
Harvard College.

This book is printed on acid-free paper, and its binding materials have been
chosen for strength and durability.

Library of Congress Cataloging-in-Publication Data
Ellmann, Maud, 1954–
The hunger artists : starving, writing, and imprisonment / Maud Ellmann.
p. cm.
Includes bibliographical references and index.
ISBN 0-674-42705-X (acid-free paper)
1. Anorexia nervosa—Social aspects. 2 Anorexia nervosa—
Political aspects. 3 Anorexia nervosa in literature. 4. Irish
Hunger Strike, Northern Ireland, 1981. 5. Richardson, Samuel,
1689–1761. Clarissa. I. Title.
RC552.A5E45 1993
306.4—dc20
92-28901
CIP

For Chris Baldick

Contents

Illustrations

Acknowledgments

The Hunger Artists was largely written at Harvard University during the term of a fellowship funded by the Andrew W. Mellon Foundation.

Many of my friends and colleagues have contributed to this book. Anne Janowitz gave me invaluable advice on both its general structure and its incidental detail. Andrew Parker first fired my interest in *Clarissa* with his masterly interpretation of the novel. Chris Baldick, John Barrell, Andrew Bennett, Catherine La Farge, Josephine McDonagh, Ian Patterson, Anita Sokolsky, Anne Swadling, Stephen Tifft, Robert Young, and Abby Zanger read the manuscript at different stages and offered many imaginative suggestions. I have also had the pleasure of discussing the issues of the book with Isobel Armstrong, Derek Attridge, Tony Crowley, Peter De Bolla, Lucy Ellmann, Stephen Ellmann, Tadhg Foley, Luke Gibbons, Simon Goldhill, Seamus Heaney, Martin Kayman, William Marshall, William McCormack, Marilyn Reizbaum, Nicholas Royle, Mary Russo, Eve Kosofsky Sedgwick, Tony Tanner, Frederick Wegener, Clair Wills, and Steven Wilson. I am indebted to Lindsay Waters at Harvard University Press for his enthusiasm and encouragement, and to Donna Bouvier for her scrupulous editing of the manuscript. Finally I would like to thank Danuta Waydenfeld for all she taught me about hunger and the mysteries of words.

THE HUNGER ARTISTS

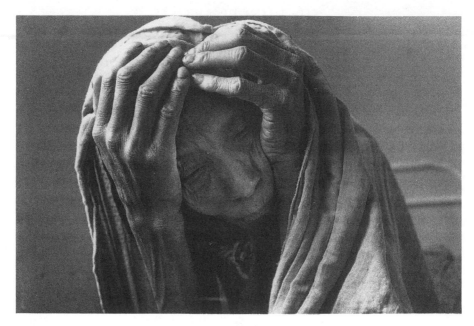

The hospital of Gourma, Mali, 1985

Autophagy

To have no food for our heads, no food for our hearts, no food for our activity, is that nothing? If we have no food for the body, how do we cry out, how all the world hears of it, how all the newspapers talk of it, with a paragraph headed in great capital letters, DEATH FROM STARVATION! But suppose one were to put a paragraph in the Times, *Death of Thought from Starvation, or Death of Moral Activity from Starvation, how people would stare, how they would laugh and wonder! One would think [women] had no heads or hearts, by the total indifference of the public towards them. Our bodies are the only things of any consequence.*

—Florence Nightingale, *Cassandra* (1852)

A few years ago a friend told me that he was going to a wake in Belfast for a woman who had been a hunger striker in Armagh, the principal detention camp for female terrorists in Northern Ireland. She had survived the hunger strike, and had even been released from prison, but had died within the year of anorexia nervosa.

What is the relationship between these two forms of self-starvation, so similar in their physical effects and yet so incommensurable in their meanings? Fasting as a protest differs so profoundly from fasting as a personal pathology that it seems almost perverse to link these two strange disciplines at all. Yet this woman plunged from the first into the second, deranging the taxonomy of self-starvation. She took her hunger with her when she left the prison as if she had become addicted to the nothingness that she had learned to substitute for food, clinging to it even at the cost of life.

Her ordeal raises many of the questions that inform this meditation. What is a hunger strike? Why is it that prisoners so often turn

to this self-lacerating form of protest? Is it possible that they are gripped by a compulsion similar to that of anorexia? Do they lose their appetite for food once they have feasted on the void and thus become "inebriate of air," as Emily Dickinson describes the jouissance of self-starvation? Is their protest merely an excuse to justify the ecstasy of disembodiment?

Or is it anorectic women who are really hunger strikers in disguise, and who are starving to defy the patriarchal values that confine their sex as rigidly as walls of stone or bars of iron? Since women succumb to anorexia more commonly than men, many feminists interpret the disorder as a symptom of the discontents of womankind. Anorexia, they argue, has now replaced hysteria as the illness that expresses women's rage against the circumscription of their lives. A self-defeating protest, since it is women who become the victims of their own revolt; and they collude in their oppression by relinquishing the perilous demands of freedom in favor of the cozy compensations of infantilism. Women get ill instead of getting organized: the anorectic turns her anger into hunger, and eats *herself* up lest she should be tempted to engorge the opportunities that she has been denied.

Whatever the causes of this baffling disorder, feminists are right to draw attention to its social implications. The anorectic, starving in the midst of plenty, has become the enigmatic icon of our times, half heroine, half horror. Her emaciated form belongs to a collective economy of images, symbolizing not only her own malaise but that of the community at large. In the Victorian era, when there was little inhibition on production, Dickens felt free to relish his heroines' plump hands without anxiety—though even he reveals the incipient hostility to fat that has come to represent the hallmark of modernity. But nowadays the image of the fleshy procreative body reawakens the Malthusian anxiety that fecundity is ecologically unsound or, more specifically, that it produces *hunger:* and, as Eve Sedgwick has observed, the moral imperative to "diet for a small planet" has transposed itself, by sleight of hand, to the clamorous demands imposed on women to "diet for a small swimsuit."[1] In the last two centuries, fat has shifted from a sign of affluence to a sign of poverty, growing fearsome in the transfor-

mation, as if the fat of the land were rising up against the class that feeds upon it. The fat woman, particularly if she is nonwhite and working-class, has come to embody everything the prosperous must disavow: imperialism, exploitation, surplus value, maternity, mortality, abjection, and unloveliness. Heavier with projections than with flesh, she siphons off this guilt, desire, and denial, leaving her idealized counterpart behind: the kind of woman that one sees on billboards, sleek and streamlined like the cars that she is often used to advertise, bathed in the radiance of the commodity. For the thin pubescent body, phallically firm, has assumed a kind of prophylactic value in contemporary culture, warding off the dangers of overproduction.

In the context of these images it is impossible to know exactly why the hunger striker of Armagh destroyed herself, or what her self-starvation meant to *her*. But even if she died of sheer despair, her hunger was a form of speech; and speech is necessarily a dialogue whose meanings do not end with the intentions of the speaker but depend upon the understanding of the interlocutor. Her body was enmeshed in social codes that preceded and outlasted its brief consciousness. In particular, it was entangled in the rival ideologies of nation, gender, and religion, and racked by all their passionate intensities. It was in the form of hunger that these forces battled for expression, ravaging the very flesh on which they were inscribed.

"The body," however, is an awkward term to use these days because it has become the latest shibboleth of literary theory, particularly west of the Rockies, where essays on the body are churned out of PCs with the same demonic rigor that the bodies of their authors are submitted to the tortures of the gym. Indeed, the theorization of the body has become the academic version of the "workout." In criticism, the cult of the body has arisen in defense against poststructuralism, and especially against the fear that "history" and "real life" have been overlooked in favor of a dangerous Gallic fascination with the signifier. In this context the body has come to represent the last bastion of materiality: if history is nothing but a narrative, "a tale like any other too often heard," and if the universe is merely an effect of rhetoric, the body seems to stand for an incontestable reality, a throbbing substance

in a wilderness of signs.[2] This book, by way of warning, is concerned with *dis*embodiment, not bodies; with the deconstruction of the flesh; and with writing and starvation as the arts of discarnation.

It was Michel Foucault who introduced the body into literary criticism, though it was his disciples who bestowed it with its talismanic properties. Foucault, on the contrary, contends that the body is an artifact of culture, constructed by the moral, medical, and scientific knowledge of its times. Marcuse, in *Eros and Civilisation* (1969), voices the popular belief, based on a misreading of Freud, that the body is repressed by civilization, which stifles its spontaneous desires; but Foucault insists that those desires are created by the very culture that deplores them. In the nineteenth century, sexuality was not denied, as it is commonly believed, but on the contrary subjected to intense surveillance; ironically, the doctors, educators, and psychiatrists who probed and codified its shameful secrets actually invented new perversions in the very effort to exclude them from the norm.[3] Even the procedures of investigation were eroticized. Far from inhibiting sexuality, medicine multiplied its avenues of satisfaction, giving pleasure an encyclopedic range. It is therefore misleading to regard the body as the repository of the instincts, held in thrall by "the conventions of Society with a big ess," as Gerty MacDowell puts it in *Ulysses*; for those conventions animate the very impulses they seem to shackle, making a fetish even of opprobrium itself.[4]

According to Foucault, cultural practices "inscribe" themselves upon the body, predetermining its "forces, energies, sensations, pleasures."[5] It is this process of inscription that Kafka literalizes in his famous parable "The Penal Colony," in which the legal sentences of the condemned are stabbed into their flesh by the needles of a diabolical typewriter.[6] But hunger exemplifies the fact that the body is determined by its culture, because the meanings of starvation differ so profoundly according to the social contexts in which it is endured. These meanings reflect both the circumstances of the starver and the forces depriving him or her of food, be they nature's dearth or humanity's injustice. Hunger may be caused by anything from famine, war, revolution, disease, psychosis, dieting, or piety, and it would clearly be reductive to equate these forces just because they work the same ef-

THE HUNGER ARTISTS

fects on the physique. While slimmers, for example, triumph in their hunger as a conquest of temptation, the Jews at Auschwitz suffered it as the extermination of their race; and the implications of their ordeals are so drastically opposed that it would be idle to contend that even the corporeal sensations were the same. Or, to take a comic example: a resident of Hollywood once remarked that the reason Richard Attenborough's film of Gandhi's life went down so well among his neighbors was that its hero represented everything that they would like to be: thin, brown, and moral.[7] Slimming has become the national religion in America, and slenderness the measure of one's moral caliber. Gandhi, on the other hand, learned to fast from his devout mother, and his hunger strikes against the British raj owed much of their effect to their roots in feminine religious practices.[8] In any case, it is clear that a life of abstinence in India, undertaken either for political or pious purposes, has a very different meaning from "life in the fasting lane" of southern California!

Hunger is the traditional example Marxists use to show that human needs are shaped by human history rather than by physiology alone. Gayatri Spivak joins this tradition when she announces in a recent interview that "there is no such thing as an uncoded body." She argues that even medical perceptions of the body are based upon a reading of its signs rather than a knowledge of its essence, for the same symptoms may be understood in different ways according to the pressures of the weltanschauung. Hunger, for example, may be read as "starving, malnutrition, fasting, dieting, anorexia, and also political fact." However, hunger has to be recoded "as a sign of exploitation" in order to become a mobilizing force in politics.[9] This is what Amartya Sen has recently accomplished in his ground-breaking work on famine, in which he shows that it is not the lack of food but the inability to purchase it that causes such catastrophes. People starve because they *have* no food, not because there *is* no food, and the problem, therefore, is "entitlement" to food, rather than its notional availability. By interpreting famine as a fluke of nature rather than a symptom of political inequities, economic policies have often exacerbated the privations

they purported to be trying to assuage. The "tradition of thinking in terms of what exists rather than in terms of who can command what," Sen argues, and the "mesmerising simplicity of focusing on the ratio of food to population has persistently played an obscuring role over centuries, and continues to plague policy discussions today much as it has deranged anti-famine policies in the past."[10]

The Marxist linguist Voloshinov uses hunger to support his case that language penetrates our innermost experience, investing the most primitive organic needs with social meanings. "Even the cry of a nursing infant is 'oriented' towards its mother," he contends. Of course, it is impossible to share another person's hunger, just as it is impossible to feel another person's pain, and both sensations demonstrate the savage loneliness of bodily experience. Nevertheless, to formulate these feelings even to oneself is necessarily to call upon the common tongue and thus to reinvoke the sufferings of others. A person may experience hunger angrily, triumphantly, resignedly, abashedly: but it is in inflections such as these that the history of the race suffuses individual experience. In fact, Voloshinov argues that the "degree to which an experience is perceptible, distinct, and formulated is directly proportional to the degree to which it is socially oriented." The hunger of a beggar, for example, summons up a multitude of cultural analogies, ranging from the fasting of the prophets in the wilderness to the anti-social protest of the vagabond. On the other hand, the hunger of the peasants, experienced "at large" but in the absence of a unifying coalition, furnishes the grounds for cults of resignation from early Christianity to Tolstoyism. It is only in a unified collective, like a regiment of soldiers, or the workers in a factory, or a social class which has matured into a "class unto itself," that the experience of hunger sheds its intonations of submission and clarifies itself as solidarity or insurrection.[11]

Rich as it is, Voloshinov's taxonomy of hunger is marred by one significant omission: self-starvation. This is probably because it is much harder to explain in Marxist terms why anyone would *choose* to hunger. It is true that in the Irish Hunger Strike, or the suffragettes', or Gandhi's, the individuals were starving in the name of a collective, be it a religion, a gender, or a nation, and their martyrdom conferred identity

on their respective groups. But this is not the case in the ascetic forms of self-starvation, which extend from the medieval saints to modern slimmers. In the current diet fad, for instance, the middle class deliberately starves itself, as if to mime the indigence from which it has released itself through centuries of exploitation. To have it but not to eat it is a sign of class superiority, betokening an independence of necessity. Yet the middle class also goes in for "roughing it," making an aesthetic or a sport of deprivation, and perhaps the fasting of the dieter partakes of this nostalgia for the lost experience of need. It is important, though, that women bear the brunt of the slimming craze today, just as they did most of the religious fasting of the Middle Ages. But female saints deprived themselves of food to discipline their sexual desires, whereas the modern slimmer starves to mortify her fat: the social stigma against women's sexuality has now transferred itself to women's fat with unabated persecutory intensity. If, as Horkheimer and Adorno argue, "the history of civilisation is the history of the introversion of the sacrifice," slimmers are even more civilized than saints, because they internalize the rites of expiation that used to be regulated by the Church.[12] Fasting and purging, they immolate their fat, blind to the social economics of their sacrifice. And when slimming crescendoes into anorexia, even the cosmetic pretexts founder: for it is clear that anorectics pursue hunger for its own sake, defying rationalizations. As opposed to female saints who fasted in an institution that controlled the meanings of their macerations, the modern anorectic starves at large, deliriously.

These examples show that in order to interpret self-starvation it is necessary to explore the cultural milieu in which the ritual occurs. In the United States, for instance, the obsession with dieting does not begin in the postmodern age but stems from the emergence of the nation, as Hillel Schwartz has pointed out in his excellent cultural history of American diets, *Never Satisfied.*[13] In the last century, however, Americans were more concerned about dyspepsia than girth. Indeed, Thackeray observed that Americans were "lean as greyhounds." Oddly, it was thought to be their gluttony that kept them thin, because

their stomachs were unable to digest the vast amounts of food stuffed into them. The solution was to "Masticate, Denticate, Chump, Grind, and Swallow," as William Kitchener prescribed in *The Art of Invigorating and Prolonging Life* in 1822. Later Horace Fletcher, known as the Great Masticator, developed a method of "industrious munching," chewing his food a hundred times a minute as a regimen against dyspepsia. Henry James took to "Fletcherizing" with a vengeance. "Am I a convert? you ask. A *fanatic,*" he wrote to Mrs. Humphrey Ward. The "divine Fletcher," he insisted, had renewed the sources of his life, and he urged his friends to grapple the system to their hearts with "hoops of steel." Indeed, it was James's Fletcherism which probably inspired Edith Wharton's famous quip about his prose, that he chewed a good deal more than he bit off.[14]

According to Schwartz, it was only after the Civil War that the fear of *fat* took hold of the American imagination, but the fear of *greed* has always haunted its prosperity. As early as 1838, Sylvester Graham, the inventor of the Graham cracker (an unforgettable feature of American childhood), wrote that "GLUTTONY and *not starvation* is the greatest of all causes of evil . . . Excessive alimentation is the greatest dietetic error in the United States—and probably in the whole civilised world."[15] According to this myth, still prevalent today, the only reason that the poor cannot afford to eat is precisely that they eat too much.

But it was in the early decades of this century that the phobia toward fat began to reach its current hysterical intensity, and it was directed then as now against fat women in particular. Of course, eating was traditionally seen as an unseemly and regrettable necessity for women: Byron, for instance, who was quite a hunger artist in his own right, insisted that "A woman should never be seen eating or drinking, unless it be *lobster salad* and *champagne,* the only truly feminine and becoming viands."[16] During the First World War, however, gluttony in women aroused abhorrence because of its suggestions not only of the indecorous but of the cannibalistic. A woman overweight by forty pounds was accounted to be hoarding sixty pounds of sugar in her excess flesh, thereby depriving her European allies of their rations. Fat women thus became the scapegoats for the guilt America was suffering about its late and grudging entry into the War; and doctors also argued

THE HUNGER ARTISTS

that fat people were unpatriotic, because the energy required to support their corpulence demanded calories that other people needed.[17]

The "philosopher in the kitchen" Brillat-Savarin, in his treatise *The Philosophy of Taste, or Meditations on Transcendental Gastronomy* (1826), pauses at a pivotal point of his analysis to contemplate "The End of the World": he argues that the gourmand, or the lover of good food, must defend the universe against the glutton, whose indiscriminate voracity threatens to hasten our annihilation.[18] In America, digestion has become the focus of the same eschatological anxieties: Americans project their phobias about their "ends," in the moral, historical, and transcendental sense, onto an obsession with the "ends" of their own bodies, with whatever goes in one end and goes out the other. In particular, the messianic aspirations of America, which should have ended in the tragedy of Vietnam, have now been resurrected in the pitiless askesis of the dieter. Having left America in 1970, I found when I returned in 1978 that the antiwar protestors of the 1960s had become the health fanatics of the 1970s, and that all the passions that had fueled their activism had been redirected inward into a preoccupation with their own physique, intensified by phobias about the toxins, like additives, cholesterol, and calories, which threatened to invade the body, cloaked in the benevolent disguise of food. In a sense the war had come home, for now it was our bodies that were under siege, rather than those of the Vietnamese; and only the most unremitting vigilance could save us from the chemicals bombarding us from every supermarket shelf.

The story of Jane Fonda typifies this transformation. She abandoned her career as antiwar radical to become the apostle of Keep Fit, exercising six (yes, six!) hours a day in a regime that bears a telling resemblance to the rigors of military training camps. Penitential as they seem, Fonda's austerities confirm Freud's principle that the neurotic ritual is "ostensibly a protection against the prohibited act; but *actually* . . . a repetition of it."[19] For the rhetoric of fitness resonates with disconcerting echoes of the war in Vietnam and suggests that the forbidden pleasures of American imperialism have resurfaced in the very discourse of their exorcism. For instance, the diet that Fonda recommends, "high-fiber, complex-carbohydrate, low-animal-protein,

low fat," corresponds to that of the prewar Vietnamese peasant; as if we could atone for the defoliation of that country by stuffing our own bodies full of leaves. Similarly, the emphasis on "fiber" suggests that the failing *moral* fiber of America might be rescued by heroic mastication of the indigestible integuments of vegetables.[20] Fiber, moreover, is cathartic, and like the food of angels it can be eaten without being absorbed: it leaves no fat, no guilt, no memory behind. Simone Weil has argued that to starve is to renounce the past, "the first of all renunciations," because it is to void the body of its stored anteriority. But in American mythology, it is fiber that becomes the magic agent of forgetfulness, because it liberates the body from the fat that represents its "frozen past," to borrow Weil's striking formulation.[21] Homeopathically, fiber frees the nation from the shame of history, disburdening its conscience of the weight of that which was. Slimming, too, depends upon the same amnesia that sustains American utopianism—the next diet will produce the miracle; the next war will be victorious and just—and all the failures of the past are merely aberrations, hiccups in our progress to beatitude.

As I have suggested, though, the history that America is trying to attentuate, or slenderize, resurges in the very rhetoric of its repression. For instance, Fonda's injunction to "go for the burn" serves at once to expiate and to *relive* the napalm raids on Vietnam; and it hints that the sacrificial rites of exercise are not so much a way of fending off the end of the world as of enjoying the apocalypse now. The fire *this* time, however, takes the form of an internal conflagration, for "the burn" is a privatized apocalypse, as cheap and easy as fast food or, more precisely, as a fast fast. In general, the rhetoric of self-improvement in America conceals an underlying drive to self-destruction, just as its narcissism masks a deeper nihilism. As Jean Baudrillard has argued, "the body is cherished in the perverse certainty of its uselessness, in the total certainty of its non-resurrection . . . Nothing evokes the end of the world more than a man running straight ahead on a beach, swathed in the sounds of his walkman, cocooned in the solitary sacrifice of his energy . . . In a sense, he spews himself out . . . He has to attain the ecstasy of fatigue, the 'high' of mechanical annihilation."[22] This aimless running gives literal expression to the fear that the uni-

THE HUNGER ARTISTS

verse is running down, as well as running out of its resources: and the craze for this strange ritual, together with the mania for "losing weight," suggests that the historic mission of America is to embody the autophagy of capital.[23]

The Irish, on the other hand, have a long tradition of starvation and the British a scandalous tradition of ignoring it. The Anglo-Irish poet Edmund Spenser was only expressing British policy when he wrote, "Great force must be the instrument but famine must be the meane for till Ireland be famished it can not be subdued."[24] His prediction came to its fulfillment in the 1840s when the potato famine devastated Ireland and averted its fomenting revolution. It was undeniably convenient for the British to let the mutinous Irish starve, whatever the principles of those involved, for genocide by neglect is less barbaric than genocide by violence. The Irish writer Bram Stoker was probably alluding to the famine in his novel Dracula (1897), in which the vampire—like the empire—feeds upon the blood of other nations (he rarely vamps his fellow Transylvanians), fattening his body by depleting theirs. The fact that the Irish in the 1840s actually described their absentee landlords as "bloodsuckers" supports the comparison.[25] On the other hand, Dracula particularly goes for British blood, which suggests that he is rather the avenger of the Irish than their predator.

Freud argues that victims of trauma repeat their terrors in their actions and their dreams in order to become the masters, rather than the victims, of their past.[26] By starving themselves voluntarily, the Irish hunger strikers of this century may still be trying to defeat the bloodsuckers and to overcome the nightmare of their history. It was after the Easter Rising of 1916 that the hunger strike began to dominate the nationalist cause, though it had also been employed by the Fenians in the nineteenth century. Yeats prided himself that he had predicted the resurgence of this form of protest in a little-remembered play called The King's Threshold (1904), discussed in Chapter 3, in which a legendary poet fasts against a king to claim the ancient honors he has been denied. However, it is much more likely that the nationalists were inspired by the recent example of the suffragettes, in spite of their

inveterate contempt for feminism. The suffragette Hannah Sheehy Skeffington claimed that she was among the first political prisoners in 1912 to go on hunger strike in Ireland, and "had we but known, we were the pioneers in a long line." At first, however, "Sinn Fein and its allies regarded the hunger-strike as a womanish thing."[27] Luke Gibbons has argued that the nationalists, in order to conceal this debt to feminism, dug up an archaic antecedent for the hunger strike in the ancient civil code of Ireland, the *Senchus Mor.*[28] Medieval Ireland, like medieval India, had a legal procedure of "fasting to distrain," known as *troscud,* whereby a creditor could fast against a debtor, or a victim of injustice could fast against the person who had injured him. The plaintiff, or "the man outside," to use the plangent terminology of the medieval text, fasted on the threshold of the house of the defendant. When a plaintiff fasted against a *nemed*—that is, a nobleman—to compel him to repay a debt, the *nemed* had to offer him a surety, or *rath,* to guarantee that he would honor the obligation. A *nemed* who refused to concede to a justified and properly conducted fast lost his entitlement to restitution for any offenses committed against him. In the words of the *Senchus Mor,* "He who does not give a pledge to fasting is an evader of all; he who disregards all things shall not be paid by God or man."[29] In effect, the *nemed* was stripped of all his legal rights within society.

This tradition found its way into Christianity: there are legends in which the patron saint of Ireland, St. Patrick, hunger strikes against God. God always relents, because capitulation in the face of such self-sacrifice was regarded by early Christians as a mark of holiness. In a seventeenth-century account of the life of Patrick, the saint ascends the Holy Mount to seek favors from the Lord only to be scolded by an angel for having asked too much. Patrick promptly embarks on a hunger and thirst strike lasting forty-five days, after which God gives in.[30] These legends suggest that *religious* abstinence may have originated in the *civil* practice of fasting with a hostile purpose against an enemy, although these traditions later grew apart. Indeed, F. N. Robinson proposes that the notion of compulsion exercised on a divinity represents a fundamental element in fasting and in other phases of religious asceticism; and what appears to the modern Christian as a form of sac-

THE HUNGER ARTISTS

rifice and humiliation may once have been, in some of its aspects, a way of taking the kingdom of heaven by violence.[31]

However, the *Senchus Mor* imposed restrictions on the faster as well as on the object of the hunger strike. If the plaintiff continued to starve after the defendant had offered to settle, his case would automatically lapse.[32] This is the most intriguing feature of the law, because it hints at the demonic side of self-starvation. Why would anybody *want* to go on starving if the purpose of the hunger strike had already been achieved? Perhaps it is precisely the restrictions imposed upon the fast that tempt the hunger striker to transgress them. If this is so, the law becomes the gateway to its own beyond, where one no longer fasts for justice but for jouissance, abandoning the codes that bind one to humanity for the intoxication of the inorganic.

This is the kind of hunger that Rimbaud celebrates in his poem "Fêtes de la faim"—festivals of hunger, feasts of famine—where he declares he has lost his taste for any food but earth and stones. To write, for Rimbaud, is to hunger, and it is only through a diet of stonecrop that the poet can accede to the inhuman solitude of art. This visionary hunger also resembles the miraculous abstinence of the medieval saints, for whom to fast was not to overcome the flesh so much as to explore the limits of corporeality, where humanity surrenders to a bodiliness so extreme that it coalesces with the bestial or divine.[33] Similarly, in J. M. Coetzee's novel *Life and Times of Michael K* (1983), the hero retreats into a burrow and starves alone while civil war is raging round him in South Africa.[34] Like King Lear, he gives up all his human superfluities in order to experience himself as bare forked animal. For Lear, too, is a hunger artist, and for this reason one could argue that Cordelia gives her father just what he is asking for, a vision of the "nothing" at the heart of things: "Nothing, my Lord." Indeed, Lear pursues this nothing with the frenzy of an addict from the moment that he gives away his kingdom until he holds the lifeless body of his daughter in his arms.

It is clear from these examples that the practice of the hunger strike in Catholic Ireland has a very different history from the cult of dieting

in Puritan America, and that their meanings are radically opposed. But both belong to an economy of sacrifice, and both are founded on the dream of a miraculous transfiguration, whereby the immolation of the flesh will be rewarded by its resurrection, in the body of a movie star in one case, or the body of an angel in the other. And these bodies are not so very different insofar as both are fashioned from a medium subtler than flesh, be it celluloid or heavenly light. So there are certain similarities between these rituals of self-starvation that override their geographical and cultural divergences, challenging traditional historicism. What is more, the hunger strikes stage-managed by the IRA unsettle chronological accounts of history because they represent what Seamus Heaney calls the "afterlife" of former protests, former macerations. By hungering, the protestors transform their bodies into the "quotations" of their forebears and reinscribe the cause of Irish nationalism in the spectacle of starving flesh.[35] A nuanced analysis of hunger strikes must recognize these intertextual and even intergastrical allusions, accounting both for the immediate conditions of starvation and also for the ghosts of past and future fasts. It is true that hunger depends upon its context for its meaning, but it is also true that *self-inflicted* hunger is a struggle to release the body from all contexts, even from the context of embodiment itself. It de-historicizes, de-socializes, and even de-genders the body, as Wole Soyinka discovers in the fifth week of his hunger strike in a Nigerian prison: "I made a strange discovery this morning," he reports. "I'm pregnant." His lower belly, he explains, has swollen up as if he had "secreted a large egg just beneath the skin" to fill the corresponding chasm in his trousers.[36]

The medieval historians Rudolph Bell and Caroline Bynum both contend that the holy women of the Middle Ages fasted for very different purposes from those of anorectic adolescents in the 1980s, and both scholars insist that these cultural discrepancies are insurmountable.[37] Yet it is striking how often anorectics appropriate the discourse of religious abstinence to justify their own voluptuous austerities. The psychoanalyst Hilde Bruch reports a conversation with an anorectic girl who claimed that she had starved herself to learn "what happens in the afterlife. Abstinence was just in preparation for special revelations; it was like the things the saints and mystics had done."[38] On the

THE HUNGER ARTISTS

other hand, an anorectic woman once informed me that self-starvation was a "quest for immorality." She meant "immortality," of course, and yet the slip reveals the strange affinity between askesis and excess: the quest for bodilessness—"immortality"—masks a darker quest for bodiliness—"immorality"—and for the most ecstatic surrender to the flesh.

This book, therefore, is neither a history of starvation nor a work of anthropology, psychoanalysis, or sociology, although it plunders those disciplines at different times. It is best described as a "phenomenology" in the sense that Gaston Bachelard has used the term, because its aim is not to find the cause of self-starvation but to follow the adventures of its metaphors. To intuit what it means for the body to reject itself, for the order of life to be overpowered by the dream of disembodiment, the language of imagination has more to offer than the language of statistics. In this nightmare, for instance, reported by an anorectic patient, the unconscious is attempting to interpret the enigma of the body's decreation of itself:

> At the cemetery, there stood a circular temple, actually only a half-circle in which a sphere was on top of a square base—the world globe . . . I hear the sounds of the words: "Now the loneliness has penetrated into you forever." Thereupon my skin gets all full of holes like a sieve, and all organs, the heart, the lungs, etc., seep through the holes to the outside until I am completely empty inside. There is only the loneliness within me and it is totally black.

The psychiatrist who cites this dream describes it as a myth of disembodiment, in which the sleeping mind is trying to envision the power against life that is devoiding the body of its substance.[39] The dreamer's body does not simply die but eviscerates itself of all its entrails in a reversal of the process of gestation. The image of the temple in the cemetery suggests that the dream is setting up a counterfaith, a dark idolatry, founded on the symbol of the *dis*carnation, where instead of being impregnated by the word, the dreamer is invaded by the "loneliness," or raped by silence. Although it is impossible to test these spec-

ulations in the absence of the patient's own associations, the dream reveals that there is something more *eschatological* at stake in self-starvation than the fashionable taste for slenderness or the equally fashionable ideology of "self-control." These are two of the most common rationalizations of the syndrome, but in the effort to explain it they explain away the *strangeness* of this discipline of disengendering. To discover what it means to live starvation, to undergo the ineluctable invasion of the void, it is necessary to explore the realm of fantasy.

This is why my ruminations concentrate on literature, although the pursuit of hunger has led me to consider forms of literature that are scarcely recognized by the academy, from self-help books to nightmares to graffiti. What these texts consistently reveal is a complicity between the themes of hunger, writing, and imprisonment. In particular, these themes emerge in two of the most incongruous examples of starvation to be found, so incongruous, in fact, that it is probably misleading to call them by a single name. The first of these is Samuel Richardson's *Clarissa* (1747–1748), the gargantuan epistolary novel in which the heroine refuses food until she pines away into her grave, inconsolable after her "honor" is despoiled. The second is the Irish Hunger Strike of 1981, when ten men starved to death in order to reclaim the status of prisoners of war after the Thatcher government demoted them to "common" criminals. Incompatible as they seem, these two stories of starvation also show a strange resemblance to each other; this book aims to bring their similarities to light while honoring their idiosyncrasies. For one thing, they belong to incommensurable realms of knowledge, since *Clarissa* is a work of fiction, whereas the Irish Hunger Strike was a historical reality. Moreover, the fictional Clarissa was a woman, while the hunger strikers of Long Kesh were men; and her agon took place in the domestic sphere, solitary and secluded, while theirs unfolded in a public institution, under the gaze of an indignant world. Nonetheless, the drama of starvation unsettles the dichotomy between the fictive and the real, between the world of language and the world of violence. It is obvious, for instance, that any form of inanition eventually leads to death, and in this sense the mimed or fictional starvation of a hunger strike ultimately converges with the real privations that it imitates. More important, the starving body is

THE HUNGER ARTISTS

itself a text, the living dossier of its discontents, for the injustices of power are encoded in the savage hieroglyphics of its sufferings.

In Kafka's story "A Hunger Artist" (1922), the unnamed hero locks himself into a cage to starve for the amusement of the populace. It is the public gaze that keeps him visible, however ruthlessly he wills his flesh to disappear, and it is only when he is deprived of this surveillance that he dies. The moral seems to be that it is not by food that we survive but by the gaze of others; and it is impossible to live by hunger unless we can be seen or represented doing so.

Self-starvation is above all a performance. Like Hamlet's mouse-trap, it is staged to trick the conscience of its viewers, forcing them to recognize that they are implicated in the spectacle that they behold. Anorectics are "starving for attention":[40] they are *making a spectacle of themselves,* in every sense. And because their exhibitionism cannot be content with any lesser nakedness than disenfleshment, they starve until their skeletons are scarcely "clad with skin" (as Richard Morton, who is usually credited with the discovery of anorexia, described a fasting girl in 1689).[41] Even though the anorectic body seems to represent a radical negation of the other, it still depends upon the other as spectator in order to be *read* as representative of anything at all. Thus its emaciation, which seems to indicate a violent rebuff, also bespeaks a strange adventure in seduction.

In the Irish Hunger Strike of 1981, it was not by starving but by making a spectacle of their starvation that the prisoners brought shame on their oppressors and captured the sympathies of their co-religionists. Representation, in all the senses of the word, determined the outcome of the Hunger Strike: for it was only when Bobby Sands was elected as MP to represent the county of Fermanagh that the world's press swarmed into Belfast to represent his starving body to the nations. However, the feature that distinguishes a hunger strike from other forms of self-starvation is the statement that supplements the wordless testimony of the famished flesh. To hold the body up for ransom, to make mortality into a bargaining chip, hunger strikers must declare the reasons for their abstinence. It is significant, therefore, that

many of the works considered in this book focus precisely on the ambiguity between the reticence of fasts and the loquacity of hunger strikes. In Victor Serge's novel *The Case of Comrade Tulayev* (written 1940–1942), the Russian dissident Ryzhik refuses to eat when he is transported back to Moscow from Siberia for his final confrontation with the Stalinist authorities. Although he is already legendary for his hunger strikes, on this occasion he conceals his fast, flushing his prison rations down the toilet and swallowing his *words* instead of food. Because of his silence the authorities do not discover his starvation until it is too late to save him for an execution of their own device. Thus Ryzhik chooses death as his last resistance to the state, rather than the deferred death of a protest fast; but it is only his refusal to declare his motives that transforms his hunger strike into a suicide.[42]

A similar ambiguity arises in *The Life and Times of Michael K,* where the hero cannot justify his self-starvation because it has transported him beyond the busy world of reasons to the knowledge of an irremediable dearth. Born with a harelip, and therefore injured in the orifice for food and speech, his inedia is doubled by an even more intransigent aphonia. In fact his utterances disappear before he voices them, as if the lack that he is fated to embody were devouring his words together with his flesh: "Always, when he tried to explain himself to himself, there remained a gap, a hole, a darkness before which his understanding balked, into which it was useless to pour words. The words were eaten up, the gap remained. His was always a story with a hole in it: the wrong story, always wrong." Mystified, the authorities attempt to squeeze an explanation out of him that will give his anorexia the status of a hunger strike and thus restore it to the realm of human meaning: "Are you fasting?" they demand. "Is this a protest fast?" Michael K, however, meets their questions with a silence as unfathomable as the inorganic world to which he hungers to return.[43]

It is this silence that hunger strikers have to break if they intend to make their self-starvation readable as protest. In this sense hunger strikes could be compared to acts of terrorism, because the force of both depends on words as much as on displays of violence. Indeed, Uri Eisenzweig has argued that terrorism is a "textual phenomenon," and he distinguishes two categories of texts involved. The first consists

THE HUNGER ARTISTS

of the statements issued by the terrorists themselves, offering rationalizations after the event for their volcanic spectacles of protest. The second consists of the media reports recording the immediate reactions to the outrage, which subsequently grow into studies, articles, and books. "The bomb flash / Came before the sound," as Seamus Heaney writes in *Station Island* (1984), speaking of the terrorist activities of Francis Hughes, the second prisoner to die in the Hunger Strike of 1981.[44] Yet this deferral between flash and sound also seems to represent the gap between the terrorist event and its textual reverberations, "between the sudden absence of matter and the traumatic appearance of words," as Eisenzweig puts it. Of all the words that terrorism generates, however, it is the statement of the terrorists themselves that is essential to the meaning of their acts. "Take that statement away," Eisenzweig contends, "and we shall be left instead with a freak incident, an individual act of madness, or, very simply, an unexplained event. Appearing as it does on a piece of paper or over the telephone, the text provided by the terrorist acts as a signature in the most performative sense of the word. Without it nothing is authenticated, no (terrorist) event can legitimately be said to have taken place. In other words, far from being a mere consequence, or even the continuation of the act itself, the existence of the accompanying text is the very foundation of the terrorist activity, its sine qua non."[45]

It is in tacit recognition of this principle that the Irish and more recently the British governments have forbidden paramilitary parties to communicate their views on television. Although it is still legal for their bodies to appear, their words are banned. It is as if the statements of the terrorists were more pernicious than the very bodies that commit the deeds. Similarly, the act of self-starvation can achieve the status of a hunger strike only through a declaration of intention. Otherwise it is reduced to the "inane," a word derived from the same root as "inanition," the latter meaning starved of *sustenance,* the former meaning starved of *sense.* To prevent this failure of signification hunger strikers must append a text of words to the mystery of their disintegrating flesh.

In the case of the Irish Hunger Strike, this text took the form of five demands for special status as prisoners of war. But the protestors

themselves admitted that their ultimatums were a pretext rather than an explanation of their sacrifice.[46] Nonetheless, their sufferings provoked a hemorrhage of media response, which gained the starvers the heroic status that their own propaganda failed to muster. David Beresford, the *Guardian* correspondent for Northern Ireland, has argued that the Hunger Strike "was one of the most intensively covered news stories in British post-war history. During those months of 1981 millions of words, 'telling the story,' poured out of Northern Ireland, to be broadcast and published around the globe."[47] Theoretically, hunger strikers achieve their ends by pressuring only the immediate authorities; it is unnecessary to involve the media unless a larger political issue is at stake. The modern terrorist, by contrast, is the monstrous offspring of the global press, engendered by the omnipresence of the media. As Baudrillard has pointed out, terrorism is "caught up from the outset in concentric waves of media and fascination," aiming "at the masses in their silence, a silence mesmerised by information." In the indiscriminate taking of hostages, for instance, terrorism strikes at the characteristic product of mass culture: "the anonymous and perfectly undifferentiated individual, the term substitutable for any other."[48]

Joseph Conrad anticipates this argument in his novel about terrorism, *The Secret Agent* (1907). Here Vladimir, the Russian anarchist, orders Verloc, his London agent, to plant a bomb in Greenwich Observatory, merely to unleash the battological invective of the press: "the blowing up of the first meridian is bound to raise a howl of execration." He insists that in order for a bombing to make any impact nowadays, "It must be purely destructive. It must be that, and only that, beyond the faintest suspicion of any other object." For terrorism strikes "wherever, whenever, whoever"; its eruptions must be sudden, isolated, epiphanic, if they are not to be normalized as murder, which is "almost an institution," or as other forms of purposive intimidation, such as ransom. The force of terrorism lies precisely in its senselessness, in its assault on teleology per se: blind as an act of nature, unbidden as an act of God. For this reason it cannot belong to a moral, temporal, or causal order of events: its only "ripples," writes Baudrillard, "are precisely not an historical flow but its story, its shock wave in the media."[49] Order as such is the "true enemy" of terrorism, how-

THE HUNGER ARTISTS

ever fiercely its agents may protest that they are fighting capitalism, imperialism, or any of the other grand abstractions. What the act of terrorism ultimately signifies, in Conrad's words, is the capacity to make "a clean sweep of the social order."[50]

It is telling that Baudrillard's account of terrorism should correspond so closely to Conrad's deeply conservative analysis, for both make the mistake of treating terrorism as a unitary phenomenon and disregarding the discrepancies between the groups, their programs, and their histories.[51] Nonetheless the kind of protest Baudrillard and Conrad are condemning differs profoundly from a hunger strike, which, far from sabotaging the idea of order, legitimates the very powers that it holds to ransom. Because its secret is to overpower the oppressor with the spectacle of disempowerment, a hunger strike is an ingenious way of *playing* hierarchical relations rather than abnegating their authority. This is not the case in terrorism, which in some ways corresponds to anorexia more closely than it does to the organized resistance of a hunger strike. The anorectic rejects the rituals of commensality that form the foundation of society, en route to a repudiation of the limits of organic life. And anorexia, like terrorism, attacks the social fabric indiscriminately, exemplifying the Foucaultian idea that power in the modern age has been decentralized among a myriad of local struggles. Like terrorism, too, anorexia depends upon the gap between the reasons and the deed: starve now, explain later, is the terroristic temporality of this compulsion. What is tragic, however, is that anorectics rarely explain themselves at all, and the explanations that they offer are designed to disavow their illness rather than to master its destructive logic. Anorectics lie, as Sheila MacLeod argues in her autobiographical account of the disorder, *The Art of Starvation*.[52] The lies of anorectics are concocted to deny the open letter of their starving flesh; they pretend that they are eating in order to preserve their emptiness inviolate. Under cover of their words, they practice the askesis of a pitiless and hollow faith forsaken by its very deities.

If anorectics lie, hunger strikers tend to underplay the motives for their gamble with mortality. The hunger strikers of Long Kesh claimed that

they were fasting to resist the prison uniform; but it is scarcely plausible that anyone would starve to death in order to wear civilian clothes. The gap between the rhetoric and the catastrophe is staggering. Nonetheless, their arguments increased and multiplied as furiously as their bodies decomposed, as if their flesh were being eaten by their words. This vampiric relationship of words to flesh typifies the literature of self-starvation, as the third chapter of this work will demonstrate. The thinner the body, the fatter the book: it is as if the lilliputian diminution of the flesh entailed a corresponding brobdingnagian inflation of the word.

The belief that words can take the place of food goes back as far as the Old Testament, specifically to the famous passage in Deuteronomy 8:3, where we are told that God humbled his people and suffered them to hunger so that they might know that "man doth not live by bread only, but by every *word* that proceedeth out of the mouth of the LORD doth man live." "If you follow this truth," Saint Catherine wrote, "you will have the life of grace and never die of hunger, for the Word has himself become your food."[53] Likewise, in the Book of Revelation (10:9), the angel of the Lord exhorts the narrator to eat the sacred book, telling him that "it shall make thy belly bitter, but it shall be in thy mouth sweet as honey." In America, however, it is slimmers who devour books instead of food, thus enjoying the apocalypse ahead of time. For the diet industry produces an enormous glut of literature that pressures women in particular to fast continuously. Foucault argues that the discourse of sexuality emerged in the confessional, where desires were enunciated rather than enacted. But now the kitchen rather than the bedroom has become the theater of temptation and the scene of sin. And the oral genre of sexual confession has been superceded by a written genre: the "confessions of a closet eater," to borrow the title of a recent contribution to the literature.[54] In these writings, all the food that the author has guiltily consumed is regurgitated in the form of words, so that the act of composition takes the place of the catharsis of bulimia. Moreover, every dieter is enlisted into the production of this literature, forsaking fork and knife for pen and ink. Even works as ideologically opposed as Wendy Stehling's *Thin Thighs in Thirty Days* and Susie Orbach's *Fat Is a Feminist Issue* present

THE HUNGER ARTISTS

the reader with the same injunction: Write down *everything* you eat. In a secular version of the Eucharist, fat is to be transubstantiated into prose. Weight Watchers now sells a magnetized food diary that sticks to the door of the refrigerator, warning the dieter to think before she acts, or more specifically to *write* before she *eats.* One wonders what historians a hundred years from now will make of this new genre, these interminable inventories of the alimentary canal where dieters immortalize their every snack. Although they write ostensibly in order to restrain themselves from eating, one could also argue that they eat in order to keep writing, since every stolen morsel represents the pretext for a further composition. What is more, their words preserve their food for future delectation, deep-frozen or freeze-dried upon the page. In this way each forbidden meal can be engorged again, re-eaten every time it is reread; and the vulgar pleasures of gustation are relinquished for the sweet deserts of writing.

More recently, a further rash of writing has been generated by the spread of anorexia, which can be seen as the demonic double of the diet fad. While there is some debate as to whether the disease of anorexia is on the rise, there can be no doubt that the research is epidemic even if the malady is not, because it has infected every discipline from medicine, psychology, and sociology to women's magazines and literary criticism. "Keeping up with the literature is a Herculean task," writes Joan Brumberg in her own contribution to the deluge, *Fasting Girls.*[55] The present volume is a relatively svelte addition to the genre, which is typically bibliophagous. Caroline Bynum's brilliant study of medieval women's attitudes to food, *Holy Feast and Holy Fast,* owes its very splendor to its intellectual voracity; and Brumberg's *Fasting Girls* is even more engorged with references, as if it were compelled to lick the data clean. In 1981, the *International Journal of Eating Disorders* was founded in the effort to digest this growing literature, and though its ultimate intention is to cure these ailments its immediate effect is to disseminate them in the public mind. Brumberg points out that the "idea of promoting a disease is not unheard of," since "Americans are competitive even about disease"; and in the absence of socialized medicine, medical researchers must routinely compete for funding.[56] Others have suggested that the textual dissemination of the illness actually

seduces many women into self-starvation. Hilde Bruch observes that a number of her patients claim to have discovered how to purge or starve from the innumerable books and television programs on bulimia and anorexia.[57] The idea that words can trigger the disorder suggests that food-refusal is a metaphor for word-refusal: for what is it that anorectics cannot "swallow" if not the very words that brought about their illness in the first place? In any case, the fact that they believe they have contracted their disorder from the media suggests that anorexia is the disease of the McLuhan age, disseminated by telecommunications rather than by contact.

Why has the theme of anorexia provoked this orgy of verbosity? Academic studies, self-help books, and autobiographical accounts of the disorder have been gushing from the presses for a decade, as if more reading meant less feeding; more words, less flesh. Since reading and writing mime the processes of eating and excreting they provide a kind of methodone for the obsession. Indeed, Susie Orbach's book on anorexia, called *Hunger Strike*, actually flaunts the blurb "Compulsive reading."[58] Even history is rewritten nowadays to discover famous anorectics of the past; it is significant that most of these have been unearthed in literature, because it reaffirms the link between starving and writing, between the hunger of the flesh and the gluttonous proliferation of the signifier.[59] Sandra Gilbert and Susan Gubar argue that self-starvation constitutes the leitmotif of women's writing throughout the nineteenth century.[60] In *Wuthering Heights* (1847), for instance, Catherine and Heathcliff copy one another's hunger strikes, each trying to outfast the other, as if they were competing for the same exhausted breast, or racing one another to eternity. Similarly, Helena Michie has observed that the Victorian novel abounds with dinners, teas, and other rituals of commensality, but that we rarely see the heroine indulge in food.[61] Dickens's *Great Expectations* (1860–1861)— which Michie oddly neglects to mention—consists of a succession of repasts, each revelatory of the class and character of its participants, and yet the central image of the novel is one of anorexia: the moldering uneaten wedding feast at Satis House, which the jilted bride, Miss Havisham, refuses either to consume or cast away. The meal becomes a metaphor for all the objects of desire in the book that can never be

THE HUNGER ARTISTS

consumed or "satis"fied. Only spiders, apparently immune to anorexia, devour the macabre banquet.

Many critics have detected signs of anorexia not only in the characters of fiction but also in their authors; and poets seem to be particularly susceptible to the disorder. Emily Dickinson and Sylvia Plath have both been diagnosed as anorectics, and their illness is interpreted as an expression of the hunger of their sex for the advantages that women are denied. If some novelists manage to escape the illness, this is perhaps because they can inflict it on their characters instead of undergoing it themselves. Richardson, for instance, was bludgeoned into dieting by his demented doctor, George Cheyne, who demanded that the corpulent and prolix novelist cut down not only on the food that he ingested but also on the words that he disgorged. "Avoid drawling as much as you can," Cheyne advised. "Readers love Rapidity in narrations and quick Returns. Keep them from dosing." Once these excess words are purged, a good vomit is the ideal purgative for excess flesh: "Your short neck is rather an argumt. for a vomit now and then . . . for no long-necked animal can vomit," Cheyne writes.[62] On such a regimen Richardson might well have perished were it not for the writing of *Clarissa,* in which he starves his heroine to slim by proxy.

Byron is another poet notorious for his austerities, particularly for his crash diet of potatoes and vinegar, which reduced his body weight by several stone. On this basis a recent article quite sincerely argues that he must have been an anorectic, for he even showed the hyperactivity characteristic of the illness, evidenced by his famous swim of the Hellespont.[63] Ludicrous as this interpretation is, it is telling that the search for anorexia in literature should lead to Byron, since it was in his era that the myth of the starving poet was promulgated in the first place. This myth arose as a response to the decline of patronage, which meant that poets had to live off their own work, while their work in turn consumed their lives, locked in a vampiric symbiosis. By the end of the nineteenth century these conditions had reached the harrowing extremes that Gissing exposes in *New Grub Street* (1891), in which the hero keeps himself alive by writing, yet also immolates his body with his own prolixity, forfeiting his very substance to the public's greed for three-decker novels. It is hardly surprising,

therefore, that the legend of the vampire was revived at the same time that the image of the starving artist was invented, for both express the fear of being eaten by one's own creation, sapped by writing, bled by words. In fact, James B. Twitchell has argued that "vampirism is implicit in the creative process itself," at least as far as the Romantics were concerned, since they conceived of art as an exchange of energies between the artist, the audience, the subject matter, and the artifact itself.[64] Each of these parts invigorates itself only by devouring the lifeblood of the others.

Michel Serres takes up this issue in his book about the "parasite" (a poor relation of the typically aristocratic vampire). He argues that the relationship between artists and their work is one of mutual consumption, in which the parasite can scarcely be distinguished from the host. The work "eats its worker," he declares, "devouring his flesh and his time; it is slowly substituted for his body. This invasion causes fear. Who am I? This, there, written in black on white, fragile, and this is my body, has taken the place of my body, frail. This is written in my blood; I am bleeding from it, and it will stop only with the last drop. The work parasites the worker . . . He dies of it. And he can do nothing about it. He lives from it. I eat my work and from it; I drink the streaming production daily."[65] It is in response to this economy that the major works of Western poetry involve a voyage to the underworld where ghosts drink blood: because the writer's bodies are devoured by the very words that guarantee their ghostdom and their afterlife.

Modern writers experience themselves as even thinner and more tenuous than their Romantic predecessors, while their artifacts have grown more bloated with their lost élan. Joyce describes the writer as a squid who disappears behind his ink, his "squidself" eclipsed by his own "squirtscreen," waning "doriangrayer" with every word that he consigns to immortality: "with each word that would not pass away the squidself which he had squirtscreened from the crystalline world waned chagreenold and doriangrayer in its dudhud."[66] André Gide actually describes his condition as a writer as a form of anorexia.[67] Similarly, in Knut Hamsun's novel *Hunger* (1890), the hero is a starving writer, and it seems to be the writing that is emptying his body, feasting words with fasting flesh. "It was like a vein opening, one word fol-

THE HUNGER ARTISTS

lowed another," he marvels. "I wrote as if possessed." "I seemed to myself hollowed out from head to toe."[68] Here the creation of the work of art entails the decreation of the artist, since his writings bleed his body dry. In Aldous Huxley's early story, "The Farcical History of Richard Greenow" (1920), the eponymous hero finds himself possessed by the spirit of a sentimental lady novelist called Pearl Bellair, who scribbles endless twaddle with his helpless hand while Greenow goes on hunger strike in order to protest against her occupation of his consciousness.[69] Yeats, in "Ego Dominus Tuus," pictures Keats with his nose pressed up against the sweetshop window, implying that his hunger was the "desolate source" of his "luxuriant song."[70] For it is when the passions "cannot find fulfilment" that they "become vision," leaving the senses and the heart unsatisfied.[71] This is why Yeats thinks that poets must be old as well as thin, because their poetry consumes their youth and potency, their visions gnawing at their vitals like the eagle that preys upon the entrails of Prometheus.

The notion that poetry originates in dearth has been resurrected in contemporary criticism, but it tends to be attributed to Jacques Lacan rather than to Yeats and his Romantic forebears. Lacan, however, envisages this dearth or "lack" in terms of castration rather than in terms of hunger. The present book, on the contrary, argues for the need to substitute a more encompassing poetics of starvation for the phallic poetics of desire. Castration is too small a sacrifice, too mild a violence, to account for the initiation of the body into language, which demands the forfeiture of every pound of flesh. The works examined in this book reveal that language and the body are locked in a struggle of attrition, in which the word is ultimately bound to triumph while the flesh is doomed to be undone. While it is easy to interpret this relationship in terms of an economy of sacrifice, whereby the immolation of the body is rewarded by the gift of words, this is to banalize its darker logic. For writing voids the mind of words just as starving voids the body of its flesh, and both express the yearning for an unimaginable destitution.[72] We do not starve to write but *write to starve:* and we starve in order to affirm the supremacy of lack, and to extend the ravenous dominion of the night.

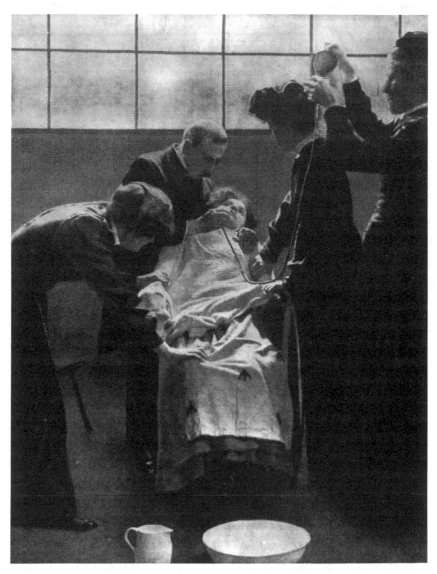

Force-feeding of British woman suffragist, 1912

Gynophagy

When a man has his mouth so full of food that he is prevented from eating, and is like to starve in consequence, does giving him food consist in stuffing still more of it in his mouth, or does it consist in taking some of it away, so that he can begin to eat? And so also when a man has much knowledge, and his knowledge has little or no significance for him, does a rational communication consist in giving him more knowledge, even supposing that he is loud in his insistence that this is what he needs, or does it not rather consist in taking some of it away?

— Søren Kierkegaard, *Concluding Unscientific Postscript*

Kierkegaard sees knowing as the intellectual equivalent of eating; but this does not mean that gluttony will make us wise. For he insists that too much knowledge is as dangerous as too little, and that a man may be famished by an excess as much as by a dearth of mental nourishment. The intellect, when it is gorged with facts, can no longer digest what it devours; and thus the route to wisdom—or to cognitive eupepsia—may entail catharsis rather than assimilation.

Kierkegaard is only one of many thinkers who implicate digestion in cognition, for the analogy between these processes is integral to Western thought. Indeed, it is ingrained into our very language. To "ruminate," for instance, means to think but also means to chew one's cud; we speak of "chewing over" an idea, of "devouring" a book, of "food for thought," and of "voracious reading." But the locus classicus of the analogy is Genesis, where man's first disobedience—or rather woman's—was to eat the apple of the tree of knowledge. One reason why the mystic anorectic Simone Weil resolved to starve herself to death was that she thought the human race was damned for woman's

greed, and therefore that it might be saved by woman's abstinence. But if eating is the route to knowledge, as the story of Genesis implies, is it possible that anorexia bespeaks a *flight from knowledge* masquerading as a flight from food? If so, the labor of starvation intimates a yearning to return to the ignorance before the Fall and to accede into the realm of the unnameable.

Eating, on the other hand, is identified with knowing from the early months of life, when the infant gets to know external objects by inserting them into its mouth, both savoring and overmastering their otherness.[1] As far as the infant is concerned, the real *is* food. However, grown-ups also cling to this delusion, particularly epistemologists, who habitually treat the intellect as a devourer and the world as the sacrificial feast to be consumed. While metaphysics strives to penetrate the thing-in-itself, uncooked by the processes of thought, epistemology—the study of the nature and the grounds of knowledge—turns its attention to the culinary apparatus of the mind.

In the latter tradition, Hegel, Feuerbach, Marx, and Freud, in spite of their divergences, agree that eating is the origin of subjectivity. For it is by ingesting the external world that the subject establishes his body as his own, distinguishing its inside from its outside. If the subject is founded in gustation, though, this also means that his identity is constantly in jeopardy, because his need to incorporate the outside world exposes his fundamental incompleteness. As Feuerbach writes, "We have nothing that is our own . . . we come on the world as have-nots, as communists, in that nothing is in us which doesn't also exist outside of us." Since we are merely "stuck together" out of water, food, and air, "we pump it all in from the outside."[2] Keats considers this dilemma in a letter to Richard Woodhouse in 1819. "One is nothing," he complains. "Perhaps I eat to persuade myself I am somebody."[3] But the catch is that the very need to eat reveals the "nothing" at the core of subjectivity. A further danger to the ego, which Freud explores, is that of being eaten from within by the very objects it is trying to engorge. In such a case starvation seems to represent the only means of *saving* subjectivity from the invasion of the other in the form of food. In fact, ingestion and starvation are less opposed than they

THE HUNGER ARTISTS

may seem, for both are destined to undo the self in the very process of confirming its identity.

In Hegel's *Phenomenology of Spirit,* the world takes the form of a vast restaurant in which the subject negates the sensuous reality of objects by gobbling them up into his consciousness. Indeed, the object has no being independent of the mind in which it is consumed. According to Hegel, those misguided philosophers who believe in the autonomous existence of external things should take a lesson from the animals, "for they do not just stand idly in front of sensuous things as if these possessed intrinsic being, but, despairing of their reality, and completely assured of their nothingness, they fall to without ceremony and eat them up."[4]

Beasts are wiser than philosophers in this respect, because instead of arguing for the intrinsic reality of objects they discredit this delusion by devouring them. Sense-certainty, or the belief that the object is independent of the subject, represents the anorexia of the philosophers, their refusal to ingest the world into the mind. Spirit, on the other hand, "does not stop at the mere apprehension of the external world by sight and hearing; it makes it into an object for its inner being which then is itself driven, once again in the form of sensuousness, to realise itself in things, and relates itself to them as desire [*Begierde*]." In this digestive system, the Spirit incorporates the object, transforming it into the stuff of thought; but it then excretes the object once again, restoring it to sensuous existence. For man maintains himself in objects "by using and consuming them, and by sacrificing them works his own self-satisfaction." The world, therefore, is "sacrificed" to spirit in the same way that a totem beast is sacrificed for the enhancement of its tribe, so that its qualities may be imbibed by its devourers.

The trouble with this "appetitive relation to the external world" is that the Spirit must annihilate the object in order to devour it. It cannot permit the object to exist at large, "for its impulse drives it just to cancel [*aufzugeben*] this independence and freedom of external

things, and to show that they are only there to be destroyed and con-sumed." Unfortunately, by denying freedom to the object the Spirit is also condemned to lose its own, in that its "desire remains essentially determined by external things and related to them." Under the do-minion of desire, then, the Spirit becomes the slave of its own appe-tites, a compulsive eater binging on the ecosphere. Only the aesthetic can offer an alternative to this bulimic apprehension of reality, as well as to its anorectic counterpart. For it is only in the realm of art that man is satisfied to contemplate without devouring the object. "He leaves it free as an object [*Gegenstand*] to exist on its own account; he relates himself to it without desire . . ."[5] While desire loses the object precisely by possessing it, aesthetic contemplation has its cake and eats it too, since it can know the work of art without negating it, leaving it unfettered, unpossessed, and unconsumed.

If Hegel uses the image of eating to describe the negation of the object by the spirit, Marx uses the same image to turn Hegel on his head—which is very hard on the Hegelian digestive system. In fact, the differences between their politics are encapsulated in their images of food. Marx complains that Hegel deprives reality of "any indepen-dence" by reducing it to fodder for the mind. On the contrary, Marx argues, man "creates or establishes . . . objects, because he is estab-lished by objects," and because the objective resides "in the very na-ture of his being." As he writes in the "Critique of the Hegelian Di-alectic": "Hunger is a natural need; it therefore needs a nature outside itself, and object outside itself, in order to satisfy itself, to be stilled. Hunger is an acknowledged need of my body for an object which exists outside it, indispensable to its integration and to the expression of its essential being."[6] So Marx insists that the subject is constituted by the very objects he consumes: you are what you eat. *"Der Mensch ist was er ißt,"* as Feuerbach puns.[7] Thus it is significant that Hegel tends to speak of "appetite" where Marx would speak of "hunger," Hegel of "desire," Marx of "need." The difference between their terminologies suggests that consciousness is better fed in Hegel's universe—a little peckish, perhaps, but never famished. In Marx's world it takes an empty stomach to recognize that consciousness is "not alone" and not sufficient to itself, but requires "another reality" in order even to com-

THE HUNGER ARTISTS

plete its own. The wisdom of starvation is the knowledge that this other reality—that of the object—can never be annulled because it occupies the very core of what we call the self.

Marx and Hegel may be right that eating is essential to the "integration" of the self, but this is only true if the food is voluntarily ingested. Force-feeding, on the contrary, demolishes the ego, as Sylvia Pankhurst reveals in her history, *The Suffragette Movement* (1931). Here she describes force-feeding as an oral rape that violates the essence of the self:

> They flung me on my back on the bed, and held me down firmly by shoulders and wrists, hips, knees, and ankles. Then the doctors came stealing in. Someone seized me by the head and thrust a sheet under my chin. My eyes were shut. I set my teeth and tightened my lips over them with all my strength. A man's hands were trying to force open my mouth; my breath was coming so fast that I felt as though I should suffocate. His fingers were striving to pull my lips apart—getting inside. I felt them and a steel instrument pressing around my gums, feeling for gaps in my teeth. I was trying to jerk my head away, trying to wrench it free. Two of them were holding it, two of them dragging at my mouth. I was panting and heaving, my breath quicker and quicker, coming now with a low scream which was growing louder. "Here is a gap," one of them said. "No, here is a better one. This long gap here!" A steel instrument pressed my gums, cutting into the flesh. I braced myself to resist that terrible pain. "No, that won't do"—that voice again. "Give me the pointed one!" A stab of sharp, intolerable agony. I wrenched my head free . . . Then something gradually forced my jaws apart as a screw was turned; the pain was like having the teeth drawn. They were trying to get the tube down my throat, I was struggling madly to stiffen my muscles and close my throat. They got it down, I suppose, though I was unconscious of anything then save a mad revolt of struggling, for they said at last: "That's all!"

and I vomited as the tube came up. They left me on the bed exhausted, gasping for breath and sobbing convulsively.[8]

In force-feeding the Hegelian economy of eating is inverted, because it is no longer the subject who consumes the object but the object that invades the subject, pulverizing her "essential being." A little later Pankhurst hints that she herself is being eaten *by* the food that she is forced to swallow, for her subjectivity disintegrates as if it had been chewed to pieces. "Sometimes when the struggle was over, or even in the heat of it, in a swift flash I felt as though my entity had been broken up into many selves . . . wildly upsurging," she recollects. "Sometimes, breaking forth, it seemed, from the inner depths of my being, came outraged, violated, tortured selves . . . I heard myself crying: 'No, no, no, no; I will not endure any more of it. I will not endure any more of it . . .' I knew not and cared not whether, if I should strive, I could silence that voice or not. I listened as to a thing apart." Here the subject seems to be reverting into objecthood: Pankhurst hears her voice as if it were "a *thing* apart," its protests drowning in the din of disconnected selves. In this predicament, it is not by eating but by vomiting her food that Pankhurst restores her sense of self-identity. To *"pull myself together,"* she writes, "I struggled till I had brought up what had been forced into me."[9] And what has been forced into her is not only the food but the ideology and even the identity of her oppressors. Under this torture, starvation rather than ingestion has become the last remaining recipe for authenticity.

Djuna Barnes actually chose to undergo force-feeding so that she might understand the anguish that her "English sisters" had endured. To her horror, this "playacting" proved as devastating as the genuine atrocity. In her account of the ordeal, she remembers her whole being "burning with revolt at the brutal usurpation of my own functions": a plight in which her last remaining refuge of autonomy lay in her ability to choke. First she describes how the doctors set the table where she was to be fed as if she were herself the feast to be devoured: "They brought me into a great room. A table loomed before me; my mind sensed it pregnant with the pains of the future—it was the table

THE HUNGER ARTISTS

on which I must lie. The doctor opened his bag, took out a heavy, white gown, a small white cap, a sheet, and laid them all upon the table." While Pankhurst sees force-feeding as oral rape, Barnes describes it as a monstrous inversion of childbirth: for the table, "pregnant with pain," is both a dining table and a table of delivery. Yet it is Barnes herself who seems to be reborn, having passed what she regards as a rite of initiation into femininity: "It was over. I stood up, swaying in the returning light; I had shared the greatest experience of the bravest of my sex."[10] The implication is devastating: to accede to womanhood is to be force-fed by men.

Another suffragist who "playacted" with force-feeding was Lady Constance Lytton, who underwent the savage ritual in Holloway Prison, disguised as a working woman named "Jane Warton." The worst indignity occurred at the end of the ordeal, when the doctor who administered the food dismissed her with a slap. "At first it seemed such an utterly contemptible thing to have done that I could only laugh in my mind," Lytton recalls. "Then suddenly I saw Jane Warton lying before me, and it seemed as if I were outside of her. She was the most despised, ignorant and helpless prisoner that I had seen. When she had served her time and was out of the prison, no one would believe anything that she said, and the doctor when he had fed her by force and tortured her body, struck her on the cheek to show how he despised her! That was Jane Warton, and I had come to help her."[11]

There is something very strange about the way that Barnes and Lytton feel that they can share the cause of women only if they reenact "the greatest trial" of their sex. It is not enough to *know* about the wrongs of woman; one must *undergo* this lacerating mise-en-scène, in which the centuries of degradation that women have endured materialize in the spectacle of violation. Nonetheless, it is hard to silence the suspicion, unwelcome as it is, that these women are obeying an unconscious *wish* to be force-fed and to experience the shattering of subjectivity that it entails. Indeed, what makes these episodes particularly harrowing is that they reawaken a trauma familiar to us all. Our first experience of eating is force-feeding: as infants, we were fed by others and ravished by the food they thrust into our jaws. We eat, therefore, in order to avenge ourselves against this rape inflicted at the very dawn

of life. The compulsive eater, who feels attacked by food, understands the truth of eating better than the gourmand, who thinks that he is eating by his own volition, or the ascetic, who thinks he can resist the imperative of food. *All eating is force-feeding:* and it is through the wound of feeding that the other is instated at the very center of the self.

To understand the intricacies of this process it is instructive to turn to psychoanalysis. For Freud, in spite of his ostensible concern with sex, is fundamentally preoccupied with food, because the act of eating represents the primal violation of the ego. In fact, it could be argued that food is the repressed in Freud, and that his vast encyclopedia of sexual malaise was constructed to evade the everyday catastrophe of eating.

It is a common misconception that hunger is a rude primeval instinct, as opposed to sexuality, which is a culturally constructed drive. According to this argument, the transition from hunger to sexuality, from the feeding breast to the erotic breast, marks the conquest of nature by culture. Sexuality belongs to the symbolic realm, hunger to the wilderness of physicality; and whereas sexuality is born in language, hunger dissipates itself in wordless cries. But the fact that hunger endangers our existence, whereas celibacy merely embitters it, does not mean that hunger is more "natural" than sex, less resonant with cultural signification. In Freud's work, the relationship between these appetites is much more complicated.

Freud's classic analysis of this relationship appears in his *Three Essays on the Theory of Sexuality* of 1905. Here he argues, first of all, that sexual desire originates in the satisfaction of the need for nourishment, and in particular in the delectation of the mother's breast: "No one who has seen a baby sinking back satiated from the breast and falling asleep with flushed cheeks and a blissful smile can escape the reflection that this picture persists as a prototype of the expression of sexual satisfaction in later life" (SE, vol. 7, p. 182). Notice that Freud says it is the "picture" that persists as opposed to the experience itself: the term implies that the object of desire is the *scene* as opposed to the *sensation* of satiety. Scarcely perceptible at first, a disjunction opens up

THE HUNGER ARTISTS

between the milk, which is the object of the need, and the breast, which is the object of desire. As Jean Laplanche has observed, sexual desire "props itself" on the experience of suckling, but also fractures this experience, because it makes a fetish of the "picture" rather than the act of ingustation.[12] This substitution means that the visionary pleasures of the image ultimately take the place of the original somatic satisfaction.

This etiology implies that the sexual drive has no object proper to itself, but only an object that it borrows from the register of hunger: the breast. Moreover, Freud points out that this first object must be lost if sexuality is to prevail. At a later stage of his argument he adds:

> At a time at which the first beginnings of sexual satisfaction are still linked with the taking of nourishment, the sexual instinct has a sexual object outside the infant's own body in the shape of his mother's breast. It is only later that the instinct loses that object, just at the time, perhaps, when the child is able to form a total idea of the person to whom the organ that is giving him satisfaction belongs. As a rule the sexual drive then becomes auto-erotic, and not until the period of latency has been passed through is the original relation restored. There are thus good reasons why a child sucking at his mother's breast has become the prototype of every relation of love. The finding of an object is in fact a re-finding of it. (SE, vol. 7, p. 222)

Thus the infant, whose sexuality has been awakened at the breast, is forced to sacrifice this partial object at the moment that he apprehends the mother as a whole; as Freud says, "He loses [the breast] just at the time, perhaps, that he is able to form a total idea of the person to whom the organ that is giving him satisfaction belongs." Once this primal object is forfeited, all future pleasures will be substitutive: for sexuality in Freud, as in Lacan, consists of the pursuit of metaphorical alternatives to lost felicities. If "the finding of an object is always a refinding of it," as Freud so plangently declares, what is found can never be the same as what was jettisoned. In this case, the object to

be rediscovered is not the milk but "the breast as its symbol," its hallucinatory counterpart.

After weaning, the infant turns to his own body for a substitute, sucking his thumb, for instance, in default of a nipple. This act marks his entry into the auto-erotic stage. At this point the pleasure of the act of sucking detaches itself from the need for nourishment and comes to be pursued as a sexual aim in its own right. What makes this substitution possible is that the breast not only satisfies the nursling's thirst but also stimulates the lips and tongue, thus preparing them for sexual enravishment. As Melanie Klein has argued:

> The first gratification which the child derives from the external world is the satisfaction experienced in being fed. Analysis has shown that only one part of this satisfaction results from the alleviation of hunger and that another part, no less important, results from the pleasure which the baby experiences when his mouth is stimulated by sucking at his mother's breast. This gratification is an essential part of the child's sexuality, and is indeed its initial expression. Pleasure is experienced also when the warm stream of milk runs down the throat and fills the stomach.[13]

According to Freud, these memories of oral satisfaction leave their traces on the membranes of the lips and tongue, marking out the mouth as an "erotogenic zone." Other such zones include the anus and the genitals which, like the mouth, originally serve digestive needs but later function as the "props" for sexuality. These orifices not only give the infant pleasure but also commemorate the mother's care, mapping her desire on his body. As zones of care, they also represent the loci of exchange, of which the primal gift of food provides the prototype for later forms of carnal and linguistic intercourse. Jean Laplanche describes them as "breaking or turning point[s] within the bodily envelope." Because they "attract the first erotogenic manoeuvers from the adult," they come to "*focalise parental fantasies* and above all *maternal fantasies*": "they are the points through which is *introduced*

THE HUNGER ARTISTS

into the child that alien internal entity which is, properly speaking, *the sexual excitation.*"[14] In effect, they are the apertures through which the desire of the other is inscribed into the self, like a forged letter in the body's broken "envelope," to borrow the epistolary image from Laplanche. According to this theory, the infant's sexuality does not properly belong to him because it is an "alien internal entity" derived from the desire of the mother and the sensory mementoes of her touch imprinted in his body's dark declivities. Even when he takes his body as his own erotic object, he is really miming the desire of the other for himself, because his very nerves are occupied by foreign powers.

Since sexuality originates in eating, it is always haunted by the imagery of ingestion, having neither an object nor a territory proper to itself. Yet eating, in its turn, exceeds the biological demand for nourishment, for it expresses the desire to possess the object unconditionally. The infant sees his stomach as a safe in which he hoards his loot, thus learning his first lessons in private property. The genesis of secrecy may also be attributed to eating, for it is well known that the best way to keep a secret is to *eat* the evidence. The stomach is a place almost as private as the grave.[15]

Most important, it is by eating that the infant establishes his body as his own, distinguishing its inside from its outside. Freud analyzes this process in a crucial passage of his essay "Negation" (1925):

> Expressed in the language of the oldest—the oral—instinctual impulses, the judgment is: "I should like to eat this", or "I should like to spit it out"; and, put more generally: "I should like to take this into me and to keep that out." That is to say: "It shall be inside me" or "it shall be outside me" . . . The original pleasure-ego wants to introject into itself everything that is good and to eject from itself everything that is bad. What is bad, what is alien to the ego and what is external are, to begin with, identical. (SE, vol. 19, p. 237)

The notion of interiority is bound up from the beginning with ingestion, and the notion of exteriority with anorexia; that is, with the sentiment that "I should like to keep that out of me." The ego is established by excluding what is not itself, and by devouring whatever it is striving to become. But this means that the ego can sustain its perilous existence only through the ceaseless purgation of itself. As Julia Kristeva explains, "I expel *myself,* I spit *myself* out, I *abject* myself within the same motion through which 'I' claim to establish *myself.*"[16] The "I," moreover, is composed of the remains of all the other selves it has devoured. Freud argues that the ego comes into existence by identifying with another being and that this process of identification originates in cannibalism. He writes: "The first [pregenital sexual organization] . . . is the oral, or, as it might be called, cannibalistic," whose aim is to "incorporate the object" into one's own body. This fantasy of cannibalism provides "the prototype of . . . identification," which later plays "such an important psychological part" (SE, vol. 7, p. 198). For this reason, identification is "ambivalent from the very first," since eating can preserve the object only at the cost of its destruction. As Freud observes, "the object that we long for and prize is assimilated by eating and is in that way annihilated as such."[17] In this conclusion Freud himself is cannibalizing Hegel, who argues that the Spirit is obliged to annihilate the object in order to incorporate it through consumption.

It is Melanie Klein, however, who provides the richest psychoanalytic theory of ingestion, for her imagination seems to be consumed with the idea of cannibalism. She argues that the infant devours all the objects of his outer world in order to install them in his world of fantasy. Since the mouth is where he has imbibed his mother's milk, it is mainly through this orifice that he partakes of his imaginary banquet. But his whole body, with all its senses and functions, participates in his incorporation of the cosmos: he drinks it with his eyes, eats it with his ears, and sucks it through his very fingertips. The traces of this infantile cannibalism resurface in our language: the object of desire, for example, is commonly described as "appetizing," "dishy," "sweet," or even "good enough to eat," corroborating Freud's idea that the cannibal "only devours people of whom he is fond."[18] Phrases such as "his

THE HUNGER ARTISTS

eyes are bigger than his stomach" or "he gobbled her up with his eyes" testify to the anthropophagous foundations of the drive to see. It is through this process of incorporation that the infant constructs an "inner world" in his unconscious, consisting of the "doubles" of the objects which exist outside his mind. Klein writes, "The baby, having incorporated his parents, feels them to be *live people* inside his body in the concrete way in which deep unconscious phantasies are experienced—they are, in his mind, "internal" or "inner" objects, as I have termed them. Thus an inner world is being built up in the child's unconscious mind, corresponding to his actual experiences and the impressions he gains from people and the external world, and yet altered by his own phantasies and impulses."[19] This theory derives from Freud's account of mourning, where he argues that the ego incorporates the objects that it mourns in order to deny their loss or disappearance. Once devoured, though, these objects vampirize the ego until the latter is "totally impoverished" (SE, vol. 14, pp. 249–253). The problem, then, is not that they have been destroyed but that they are never *dead enough,* because they feed upon the living ego like the famished specters of the underworld. Similarly, Klein argues that the infant's objects are entombed "alive" in the catacombs of the unconscious, like the living corpses in the crypts of Poe. Her Gothic fantasia of mansions, walls, crypts, and dungeons suggest that the very notion of enclosure derives from the dynamics of incorporation. In a case of claustrophobia, for instance, she argues that her patient's fears of being locked into a cage symbolize his deeper terror of the vengeful objects imprisoned in his gluttonous unconscious.[20]

Taking up this imagery, the French psychoanalysts Nicolas Abraham and Maria Torok have redescribed incorporation as a process of "encryptment," whereby the ego is transformed into a keep or mausoleum haunted by the victims of its own devouring love.[21] And just as Poe's cadavers burst out of their cerements, bringing down the houses constructed to contain them, so these phantoms ultimately overwhelm the ego in which they are entombed. When they become "too numerous," Freud writes, "unduly powerful and incompatible with one another," these objects "gain the upper hand" (SE, vol. 19, p. 30). When this happens the ego can no longer claim to be the master

of its mansion, because its own incorporated objects eat it out of house and home.

Psychoanalysts under the influence of Freud and Klein have tended to interpret anorexia as a defense against the fantasy of cannibalism. Helmut Thoma, for example, argues that his anorectic patient Henrietta A. avoided food because she had unconsciously associated oral satisfaction with destruction.[22] According to Karl Abraham, the refusal of food in depressive states signifies remorse for the "disaster" wreaked in the imaginary world by cannibalism.[23] By starving, the anorectic is attempting to atone for this disaster, yet also fending off the vengeance of the objects that her ego has engorged. If every meal is something of a Eucharist, symbolizing the incorporation of a lost or forbidden being, self-starvation represents an exorcism of the ghosts encrypted in the graveyard of the ego.[24] This interpretation is confirmed by anthropology, for there are cultures that prohibit eating during the period of mourning in order to prevent the ghost of the dead person from entering the body with food.[25]

The model of cannibalism is misleading, though, if it is understood to mean that the subject eating and the object eaten are discrete and fully constituted entities. Whether the subject annihilates the object or the object overwhelms the subject, they both remain entrammeled in the endless seesaw of antitheses. Freud, on the contrary, is not concerned with either subject or object as a *whole,* but with the *parts* that circulate between them. Milk, for instance, is the currency that binds the mother and the child in their first exchange, their primary economy. Later on, Freud argues, other objects come to function as equivalents for food. The feces, for example, are the infant's "first gift," the original possession surrendered to the mother in exchange for nourishment and love. In the unconscious mind, feces, babies, gifts, and money are regarded as "symbolic equations," because they are objects that belong to the subject but may also be detached and yielded into the possession of the other.[26] It is through these circulating objects, which Lacan has described as the subject's exchange-values, that

THE HUNGER ARTISTS

the infant explores the boundary that divides his body and its products from the interpsychic merchandise of others.

This notion of the "symbolic equations" of the unconscious underlies one of Freud's most startling insights into anorexia, which is couched as an aside in his 1931 essay "Female Sexuality." Here in a few unguarded words he casts his whole contentious theory of penis envy into doubt. After arguing that girls reproach their mothers for depriving them of penises, he adds that a "second reproach," and "rather a surprising one," is that their mothers *did not give them enough milk* (SE, vol. 21, p. 234). His only comment is to doubt that any quantity of food could satisfy the infantile libido; but in this way he evades the question as to whether this insatiable form of hunger is specific to the tragedy of femininity. What he does imply, however, is that the girl conceives of both the penis and the milk as gifts at the disposal of the *mother* and covets both as interchangeable commodities. Here Freud anticipates Klein's view that infants attribute the penis to the mother rather than the father, equating it with all the other hidden treasures, such as food and babies, that they yearn to gouge out of her body. It is not the purpose of this book to debate the merits of these schools of thought; yet it is possible that by suppressing milk in favor of the penis, and by assimilating hunger into sexuality, Freud is neglecting what is most unique to femininity and most resistant to the phallic regulation of desire. It is not only the penis that women imagine they lack, but the very pabulum of life. *Femininity is hunger.*

If food is equated with all the other objects on the interpsychic circuit of exchange, refusing food can mean as many things as food itself, as the prolific literature of anorexia confirms. One famous psychoanalytic study attributes the disease to a confusion between food and babies, whereby eating represents insemination, the stomach represents the womb, and the constipation endemic to the ailment represents the fetus in the abdomen.[27] While this theory seems overingenious, another influential article asserts that food can represent "the breast, the genitals, faeces, poison, a parent, or a sibling," while eating symbolizes concepts as diverse as "gratification, impregnation, intercourse, performance, growing, castrating, destroying, engulfing, killing, cannibalism."[28] The variety of these interpretations demonstrates

that food is *metaphorically* omnivorous, changing everything into comestibles in the same way that money changes them into commodities. It is the polyvalence of food that enables anorectics to transfigure all their thoughts and feelings into dietetics.[29] They starve their language as they starve their flesh until inappetence becomes their last remaining idiom.

One of Helmut Thoma's anorectic patients sees food and impregnation as identical because they both entail a violation of her self-identity: "Bottle—child—disgust, if I think of it—injections—the idea that there is something flowing into me, into my mouth or into the vagina, is maddening—integer, integra, integrum occurs to me—untouchable—he does not have to bear a child—a man is what he is—he does not receive and he does not give."[30] These free associations lend credence to Freud's view that food and babies are synonymous in the unconscious, for the patient treats them as equivalents, dreading both as threats to her autonomy. Perceiving food as something flowing into her, rather than something actively consumed, Thoma's patient fears she will be raped by what she eats, invaded by the other and defiled. By starving she is trying to preserve her ego—"integer, integra, integrum"—against a world that infiltrates her every orifice. If she fears pregnancy it is not because she is afraid of babies or even of the pain of giving birth, but because it means that she must sacrifice what Margaret Atwood calls her "uncontended possession" of her own body.[31] "A man is what he is," whereas a woman always runs the risk of being more than what she is, or two-in-one. If this patient wants to be a man it is because she thinks "he does not receive and he does not give," and therefore that he can escape exchange and its concomitant dismemberment. Only by rejecting any "flow," or influence, from others, be it the "bottle" or the "child," can she preserve her body whole, her self inviolate.

A self-portrait by another anorectic woman (see drawing) also indicates the fear of being self-divided, two-in-one. The artist described the spikes around her body as the "forcefield" which protected her against the world, excluding friendship and hostility alike. If their purpose is to keep the other *out,* however, they are also keeping something *in:* that is, the doppelganger imprisoned in her abdomen. The

THE HUNGER ARTISTS

artist identified this figure as "the fat person who was trying to get out." Her sense that her body had been occupied by a devouring alien confirms the notion that the ego is besieged by the internal victims of its cannibalism. But eating is confused with impregnation, too, because the "fat person who is trying to get out" has clearly been depicted as a fetus gestating in the womb, although the artist seemed to be unconscious of this innuendo. Apart from pregnancy, the figure shows no signs of femininity, nor indeed of any sexuality at all: even its glass womb is probably a stomach in disguise, and its homunculus a product of the infantile fantasy that babies are composed of food.[32] Indeed, the picture expresses not only a repudiation of the feminine but of the whole adventure of sexual difference.

However, there are other features that complicate this reading, since almost every detail is duplicitous. The spikes, for instance, are supposed to frighten others off, but they also call attention to the self, because they make the body look as if it were alight, encased in flame. Indeed the picture bears a curious resemblance to William Blake's depiction of Glad Day, with its triumphant figure ringed in solar rays. In

the same way, the artist wishes to repress her greed by imprisoning her "fat" self in her thorny spine. Yet her picture also intimates the opposite desire: to give birth to her own immensity. Within the hollow center of this diabolical persona another selfhood, fat with sensuality and power, struggles vainly to be born. The ostensible desire to be thin, integral, and immaculate is subverted by a secret longing to be "great with" food and babies and to swallow up the universe into the self. As Lewis Hyde puts it, "The desire to consume is a kind of lust. We long to have the world flow through us like air or food. We are thirsty and hungry for something which can only be carried inside bodies."[33] Likewise, the wish to be enwombed conceals a deeper wish to be reborn and to be fat enough to burst out of this chrysalis of fire.

"I grew up kissing books and bread," Salman Rushdie writes in a reminiscence of his childhood in India. Whenever anyone in his devout Islamic home allowed a slice of bread to fall or dropped a book, "the fallen object was required not only to be picked up but also kissed, by way of apology for the act of clumsy disrespect." Bread and books, he explains, had to be treated with the same reverence because they represented "food for the body and food for the soul."[34]

Up to now this chapter has been dealing with the tortuous affinities of food and sex. But Rushdie's homology of bread and books, or food and words, is even more important to the phantasmatics of ingestion. For it is only in the world of words that food can function as a metaphor for sex at all, or sex as a metaphor for food. Yet the fact that language issues from the same orifice in which nutrition is imbibed means that words and food are locked in an eternal rivalry. "The mouth speaks with its tongue and tastes flavors," wrote Saint Catherine, who gave up food in order to incorporate the word of God.[35] Since language must compete with food to gain the sole possession of the mouth, we must either speak and go hungry, or shut up and eat.

Gilles Deleuze and Félix Guattari have argued that the "mouth, tongue, and teeth find their primitive territoriality in food."[36] Later on, this territory is usurped by speech, which is founded on forgetfulness of food. But speaking also mimes the act of eating and thus

THE HUNGER ARTISTS

restores its primitive enjoyments in a different form. As we acquire speech we sacrifice the pleasures of ingestion for the thrill of sculpting vocables within the mouth: "not shaping pellets of information or handing ideas from one to another, but rolling words, like sweets on [the tongue]; which, as they thinned to transparency, gave off pink, green, and sweetness," as Virginia Woolf writes in *Between the Acts.*[37] In this sense speech is a form of fasting, and writing represents an even fiercer abstinence than speech, although it is easier to write than to speak with one's mouth full. It is revealing that we devour *books,* not speech, and that we *read,* rather than *hear,* "voraciously": these expressions hint that the written word can actually take the place of food, whereas the spoken word is too ethereal for nourishment.[38] In writing, language is emancipated from the mouth and ultimately from the body as a whole, in that the written word outlives the mortal flesh.

It is with speech, however, that the process of disembodiment begins. Ella Sharpe, in a classic psychoanalytic article on metaphor, argues that the infant establishes his sphincteral control over his orifices at the same time that he acquires the power of speech, which opens up a different "avenue of 'outer-ance.'" The activity of speaking "is substituted for the physical activity now restricted at other openings of the body, while words themselves become the very substitutes for physical products." Since speech itself provides "a way of expressing, discharging ideas," it offers the infant an alternative to physical evacuation. Sharpe argues that metaphor bears witness to the excremental origins of speech: for instance, one of her analysands complained, "I am sodden with despair"; another, "I can't control my thoughts"; and another, "this couch reeks with verbosity."[39] All these metaphors, especially the last, imply that physical incontinence has been supplanted by garrulity; for the emotions, trapped at other orifices, have been forced to issue from the mouth in logorrhea. What this means, however, is that the *ex*pression of the word requires the *re*pression of the flesh. By substituting utterances for emissions, speech usurps the functions of the body, conscripting soma into seme.

Critics of Sharpe have pointed out that many of the expressions that she cites are clichés ingrained in the collective consciousness. It

is probably because she conceives of language as *expression* that she neglects the public import of these metaphors and focuses upon their personal significance. How words *get out* engages her attention more than how they find their way into the mind. By concentrating on the egress of language through the mouth she overlooks its ingress through the ear and thus ignores its intersubjectivity; she forgets that the act of listening precedes the act of speech, and that the ear must "drink" before the mouth can "run." But Stuart Schneiderman has argued that it is precisely this confusion of the mouth and ear that gives rise to bulimia and anorexia, because "it is not obvious to the unconscious how it happens that words enter the ear to [exit] the mouth."[40] Bulimic vomiting imitates the act of speech, regurgitating food as a substitute for words; and the symptom derives from the delusion that language is ingested through the same orifice from which it is disgorged. Virginia Woolf seems to have suffered from the same delusion, for she admitted to the fear that overeating led to hearing voices, as if she were invaded through the mouth by other people's words.[41] This fantasy is not so very different from the old tradition that the bards receive their inspiration through the mouth rather than the ear, like the poet of "Kubla Khan" who feeds his words with honeydew and drinks the milk of paradise.

This is soul food: but the binge-purge cycle of bulimia also emulates angelic eating, because "the substance of food is prevented from changing into the substance of the body."[42] Victoria Shahly, another psychoanalyst, has argued that bulimics are acting out the very principle of metaphor. Just as metaphor "is a way of 'saying' something without actually saying it," so bulimic vomiting provides "a means of 'eating' food without actually eating it." According to Shahly, bulimics are "possessed" by the metaphor of food, because they are compelled to take it literally, translating all their impulses into digestive terms. One of her patients told her, "I felt so bad I came home and threw up." Whereas her family would figuratively explode at the dinner table, she would "stuff" her anger but literally disgorge her food in private. After all, she could only "swallow" so much. Since this patient was the daughter of survivors of the Holocaust, Shahly suggests that metaphor particularly appealed to her because it can increase the ex-

pressive possibilities of language while economizing on its limited resources. "To make a single word or image 'serve' to express multiple meanings" compares to rationing or to "the economical distribution of food during wartime." The patient's parsimonious attitude to words also expressed her guilt for being fed, unlike her parents, who had starved in Auschwitz. To overcome her illness, she had to reconstruct her symptoms in symbolic terms. Gradually she learned to "'eat her words' instead of food," and grew more fascinated by the *metaphor* of eating than the *act*.[43] Her story hints, however, that the triumph of metaphor depends on the suppression of the realm of food, which comes to represent the netherworld of language, its dark continent.

Mary Gordon's powerful first novel, *Final Payments* (1978), explores this struggle between words and food and shows how women in particular become the victims of their rivalry.[44] The heroine of the novel, Isobel, has spent the last ten years nursing her disabled father, whose Catholic funeral takes place at the beginning of the book. Her only rival for this role was Margaret, their former housekeeper, who had hoped to become her father's wife. But Isobel, detecting her designs, had persuaded her father to dismiss her and had thus become the Pyrrhic victor of the Oedipal romance. After her father's burial, Isobel at first appears to be serene: she buys herself some clothes, sells the family home, and enters into a passionate liaison with a married man. But her newfound happiness is shattered by a sudden tirade from her lover's wife, a woman much like Margaret, full of "lacks" and disadvantages for which she holds the fortunate to ransom. This traumatic interview plunges Isobel into the agony of guilt that she had temporarily forestalled. Baffled by grief, the only penitence she can imagine for her crimes is to devote herself to the repulsive Margaret. She goes to live with her, relinquishing her lover, and in this dank and cheerless home embarks upon a kind of eating strike, stuffing herself with all the food she can devour although she is incapable of either hunger or satiety. In psychoanalytic terms, this cannibalistic regression drives her back into the "oceanic" world of early infancy, in which there is no boundary between the baby and the breast, between the eater and the

edible. Even the boundaries of her body disappear, for Isobel experiences fat as indeterminacy rather than solidity, feeling that the outlines of her own gestalt are dissolving in a sea of food: "The food I ate turned into flesh, and that was what I would think about, too, as I lay in my bed—food turning into flesh, my stomach growing softer and rounder in front of my bones, my breasts getting heavier and seeming to drop from my body, the insides of my thighs growing into one another, so that they chafed and rubbed together as I walked" (278). Paradoxically, she experiences her enlargement as a form of self-erasure, as if she were eclipsed by her own fat, effaced by her own face: "Every day, I would see my eyes get smaller, my face more taken up with face, with flesh" (278).

Gluttony, for Isobel, symptomises several incompatible desires: one, to incorporate her father in order to deny his loss; another, to devour Margaret in order to identify with her but also to destroy her. The more Isobel eats, the more she looks like Margaret; she seems to take her over, like a body snatcher. And even though she thinks she is sacrificing everything to Margaret, this gift reduces its receiver to a quivering gelatinous dependency: "'What will happen to me . . . ?' said Margaret, beginning to whimper" (306). Under the alibi of paying Margaret off, having robbed her of her father's marriage, she is also paying Margaret back, completing her revenge on her competitor. But Isobel is particularly fascinated by the alchemy whereby food is transfigured into flesh: "The food I ate turned into flesh . . . food turning into flesh." The incantatory repetition of this theme suggests that she is paying homage to Communion, another cannibalistic feast in which food is converted into flesh. She is binging, then, in honor of her father's faith and the Catholic interpretation of the Eucharist, whereby the bread and wine are not supposed to *symbolize* the Savior but actually to *be* his body and his blood.

The born-again Christian Cherry Boone O'Neill also expresses this confusion between food and flesh in her autobiographical account of anorexia. Her memoir opens with a sinister Communion conducted in her parents' home, her father acting as officiating minister. The author, meanwhile, is frantically counting up the calories in the Communion wafer and in the grape juice masquerading for the wine: "My

mind was computing feverishly: crackers are about twelve calories and I'll probably eat about one twelfth, so that's one calorie, and grape juice . . . Too many. I'll just pretend to drink the grape juice. Hey, maybe I can pretend to eat the cracker, too! Then I can just smash it between my fingers and sprinkle the crumbs on the floor. No calories!"[45] While Protestants are meant to think that the bread and wine are *metaphors* for Christ, O'Neill adopts the Catholic attitude: she is gripped by the belief that food *is* flesh, and that even the most tenuous angelic nourishment is immediately transubstantiated into fat. This literalism culminates in the blasphemous idea of smashing the communion wafer and besoiling her parents' carpet with the crumbs of its deconstituted metaphor.

In *Final Payments,* it is precisely the recovery of metaphor that breaks the spell of food for Isobel and frees her from its suffocating literality. Her rapacious eating stands for a preverbal or abortive metaphor that she cannot even bring to consciousness until her last defenses against mourning have been shattered. "I had been selfish," she utters at last. "I could have devoured the whole world with my greed" (274). This metaphor enables her to deliteralize her greed by translating it back into "the universe of things said."[46] But it is the dead father, in his various deputed forms, who heralds the return of figurative speech: for in this book, as in the theories of Lacan, the symbolic order is personified as masculine. At first, the paternal principle assumes the form of a letter from her lover Hugh, which infiltrates her oral and maternal universe of food. "I ache for you. I long for you," he writes (284). This letter sends a "wave" across her stomach, which Isobel mistakes for nausea until she recognises it as sexual arousal (285). The confusion is significant because it shows that sexual desire not only turns her off her food but occupies the very territory of ingestion. And it is the desire of the *other,* not her own, that usurps her body from without and subjects her to its alien imperative. Moreover, it is crucial that the *letter* rather than the *presence* of the lover should revive her sexuality. It is not his *touch* but his *writing* that extricates her from her wordless symbiosis with the edible, restoring her to language and desire. "He had written to me," she reiterates: "Now the mark of him was on me" (286). By writing *to* her he has also written *on* her,

inscribed her as the object of his own desire, and readdressed her body as a letter to himself, an s.a.e. Soon afterwards she undergoes a further marking: she submits herself to being measured for a dress, and her body, which had seemed amorphous, infinite, is sternly circumscribed to "size sixteen" (292).

In the end, it is the father's closest friend, a Catholic priest, who intervenes between Isobel and Margaret, breaking up their mutual vampirism. Like Hugh, however, Father Mulcahy does not present himself in person but makes his first approach to Isobel by telephone. The only word that she can bring herself to utter when she hears his long-missed greeting on the line is "Father." By assuming the role of the symbolic father, he frees her from engulfment in the real. "I had nearly killed him," Isobel thinks. "But he had not died" (290). With this realization she is able to renounce the fantasy of cannibalism because it has been robbed of its omnipotence, its magic. What is most important, though, is that the lover and the priest do not intrude directly but only in a mediated form, because their absence seems to be more therapeutic than their presence. It is not these men themselves who rescue Isobel but the networks of exchange they represent: the post, the telephone, the world of commerce. It just so happens in this novel that the *mail* is represented by the *males*. Through their intervention, communication at a distance takes the place of the umbilical exchange of food and flesh. Since a phone call is a voice without a speaker, as a letter is a text without an author, both are ghosts: and both enable Isobel to come to terms with absence and a universe of phantoms. Only then can she accept her father's death, disgorge him from her ego, and allow him to return in his symbolic forms. At this point she also realizes that she can sacrifice her money rather than her life to Margaret, thus substituting the symbolic for the real. She gives her all her money and, exhilarated by the loss, absconds to freedom.

The catch, however, is that Isobel must forfeit her own flesh in order to regain the world of words. Her first response to her return to language is to skip her lunch. Indeed, the more she speaks, the less she eats; her body lightens, as if it were devoided by her own loquacity. By the time she is ready to relinquish her gynophagous relationship with Margaret she describes herself as "weightless," "bodiless," "in-

THE HUNGER ARTISTS

visible," but full of words: for the last sentence of the novel reads, "There was a great deal I wanted to say" (306–307). Having initially relinquished words for food, she turns full circle in the end and resolves to diet in order to replace her fat with speech. Thus she fasts her way back into language as into a garment that will always be at least one size too small. What the novel shows is that language is a sacrificial order, exacting every pound of flesh, and that it is woman who is doomed to make this "final payment."

It is through the act of eating that the ego establishes its own domain, distinguishing its inside from its outside. But it is also in this act that the frontiers of subjectivity are most precarious. Food, like language, is originally vested in the other, and traces of that otherness remain in every mouthful that one speaks—or chews. From the beginning one eats for the other, from the other, with the other: and for this reason eating comes to represent the prototype of all transactions with the other, and food the prototype of every object of exchange. No one is "completely weaned," Michel Serres has argued: we all carry "a pump or a sucker, whether visible or invisible," an umbilical attachment to the other.[47] Because every mouthful testifies to the seduction and annihilation of the other, it is impossible to eat alone. But it is equally impossible to starve alone, since self-starvation also importunes the other, if only to defy its alimentary dominion. And hunger is a form of invocation whose meanings are as multifarious as food itself.

Lacan interprets anorexia as an apostrophe addressed to the absent or begrudging breast of infancy. He argues that the breast as the primordial object of desire yields either something or nothing. After the breast is lost, infants normally console themselves with substitutes like food, drink, or sexual acts. But in the case of anorexia, the oral drive becomes infatuated with the nothingness itself and cannot stomach any substitutes for its vacuity. The anorectic *does* eat, but what she eats is nothing; and she refuses food out of allegiance to the nullity that she incorporated at the breast, unwilling to let any taste adulterate this emptiness.[48] Thus her fate is to embody the abyss that food and words are both concocted to conceal, the lack at the foundation of the

vital order. She hungers to debunk the myth that any food could fill this void, or any metaphor assuage its desolation.

By identifying with the empty breast, the anorectic is also trying to disown the burden of an independent selfhood. In fact, many of her rituals suggest that the roles of self and other have reversed themselves, that she has turned her inside out, her outside in. A common symptom of the illness is the preparation of elaborate meals that the anorectic refuses to consume: for she projects her hunger onto others and by feeding them attempts to satisfy her appetites vicariously. Orbach argues that the anorectic has disowned her feelings so completely that the other is obliged to feel them for her. Our impulse to bolt at the sight of her emaciated form is a projection of her own desire to escape her deadly regimen.[49] For there is something about hunger, or more specifically about the *spectacle* of hunger, that deranges the distinction between self and other. This is what charities like Oxfam are exploiting when they use photographs of famine victims to solicit our unconscious feelings of complicity. Who could fail to be moved by the small brown wide-eyed face, the swollen belly, and the bony limbs of some poor naked starving Third World child? The daily newspapers are stuffed with such pornography. Yet the message of these images is mixed, because they flatter our delusions of cultural superiority at the same time that they appeal to our forgotten past, to the famished and abandoned infant in ourselves.

It is these unconscious resources of guilt that hunger strikers also have to tap if they are to triumph in their death-defying gamble. Somehow they must persuade the people whom they fast against to take responsibility for their starvation. In this way hunger strikers reveal the interdependency in which all subjects are enmeshed, because they force their antagonists to recognize that they are implicated in the hunger of their fellow beings. At the same time, though, the strikers turn their rage against their enemies upon themselves and immolate themselves in effigy. Their suicide is murder by proxy. Through this interpsychic ping-pong of projections, the spectacle of hunger overrides the bounds of subjectivity. It forces us to feel each other's feelings, think each other's thoughts, and inhabit one another's tortured

flesh. Indeed, it is akin to the phenomenon that Freud, a little sheep-ishly, denoted as "telepathy."[50]

Joyce, too, associates telepathy with the digestive processes, for he suggests that the transference of food within the uterus provides a model for the transference of thought. In the Proteus episode of *Ulysses,* Stephen Dedalus contemplates his navel, the original digestive orifice through which the fetus feeds upon its mother in the womb. He compares the umbilical cord to a telephone wire—the "strand-entwining cable of all flesh"—which hooks the human species back to its first progenitors in "Edenville." Thus in his imagination the world of telecommunications is transformed into an interminable "navel-cord" in which all speakers are enmeshed, parasiting one another's inmost thoughts.[51] In this context, to refuse food would be to deny the other at the cost of the annihilation of the self: it would be to sever the umbilicus of intersubjectivity.

The way to a man's thoughts is through his stomach: this is what Huxley also hints in his "Farcical History of Richard Greenow," where the hero's body is invaded by force-feeding in the same way that his mind is invaded by the sugarcoated thoughts of Pearl Bellair. Another example may be found in Stoker's *Dracula,* where the heroine, Mina Harker, discovers that she can read the vampire's mind after she is forced to suck his blood from the wound that he has cut into his breast.[52] In this scene (282), bloodsucking becomes a metaphor for nursing and for oral sex, but also for the interchange of language, since it is words as well as blood that pass between these anthropophagous telepathists. Dracula, in turn, consumes his victims' thoughts in the process of devouring their blood: "there is something preying on my dear girl's mind," says Arthur Holmwood of the much-vamped Lucy (109). Indeed, the novel hints that language is itself a form of vampirism: in speaking as in eating, the human species feeds upon itself, sucking words and sucking flesh in an endless convoluted plagiarism. To emphasize this parallel, the text consumes the characters' confessions in the same way that the vampire consumes their blood. While their bodies are subjected to transfusions, their writings are subjected to transcriptions and engorged into the master narrative. At the end,

the hero of the novel opens up the safe in which these writings have been squirreled away and finds that so much of the material has been transcribed that "there is hardly one authentic document" among the "mass of typewriting" (378). And there is scarcely an authentic corpuscle among the copyists who preyed upon these texts, because their blood has been purloined from others' veins. Vampirism is infectious: and the spread of vampires bespeaks the spread of empires, insofar as both create "a new and ever-widening circle of semi-demons to batten on the helpless" (51). But the epidemic also mirrors the venereal transmission of the narrative itself, as it passes on from hand to hand and mouth to mouth. The "zoophagous" lunatic, so named because he wishes to absorb as many lives as possible into his own, comes to personify the text itself, glutted as it is with letters, diaries, telegrams, recordings, invoices, bulletins, and newspapers (70).

In eating, we consume the flesh of others; in telepathy, we eat their thoughts. Thus telepathy subverts the privacy of minds, eating the privacy of bodies; for both reveal the presence of the other in the haunted house of subjectivity. If our thoughts are not our own, nor is our flesh, because our bodies are composed of what we eat, and what we eat is always foreign to ourselves. Eating, then, confounds the limits between self and other, and it is partly to protect these limits that Americans have grown so vigilant about their diet. The American term "substance abuse" epitomizes the anxieties involved: any substance, even a benevolent one like food, becomes toxic when it reveals the insubstantiality within, the dependence of an inside need upon an outside supplement. The term "addiction" now extends to smokers, eaters, junkies, and even "workaholics," oblivious to any difference between their "substances." Those few who are left over, the thin, the sober, and the lazy, become epistemological vigilantes, abusing the abusers for challenging the limits of the self. Addiction means that my substance is not inside but outside, and in my craving for my fix I violate my self-identity.

The term "abuse" recalls the antedated term for masturbation, "self-abuse," and much of the opprobrium against addiction probably derives from this association. Indeed, Freud described masturbation as the "primal addiction" (SE, vol. 1, p. 272), and he argued that it should

THE HUNGER ARTISTS

be treated, like "any other addiction . . . in an institution under medical supervision." "Left to himself," he warns, "the masturbator is accustomed, whenever something happens that depresses him, to return to his convenient form of satisfaction" (SE, vol. 3, p. 275). Victorian as they seem, the same strictures are leveled nowadays against "food-abusers," and moral outrage is still masquerading as medical concern. The hospital has supplanted the confessional, while the psychobabble of "compulsive eating" has replaced the moral rhetoric of "greed." Like masturbation for Rousseau, eating has come to represent the "dangerous supplement" to heterosexual relations.[53] This is why fat people are reviled, since they not only indulge in onanistic pleasures but flaunt them in the unconcealable abundance of their flesh. Indeed, the more they eat, the more they *show*. The fat person is "out of control": fat is the enemy within the body, like Communism in the body politic, which threatens to subvert the very notion of self-governance. But fat also stands for the return of the repressed, for something that *should not show* but that has come to light. What exactly is the dreadful secret? Can it be so appalling that we *like to eat?* The crime is scarcely worthy of the punishment, except that fat has now become the symbol of a welter of anxieties ensnarled in the term "abuse." What fat means is that "abuse-value precedes use-value," to borrow Michel Serres's terminology.[54] It means that culture precedes nature, and that addiction is earlier than need. It means, at last, that hunger is insatiable in essence, and that life is the *grande bouffe* in which we have no choice except to eat ourselves to death—or starve.

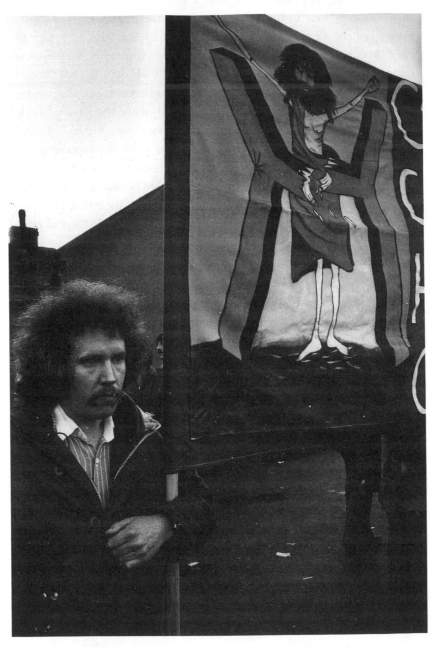

Demonstration for hunger strikers in Market area of West Belfast

Sarcophagy

Art thou the thing I wanted?
Begone — my Tooth has grown —
Affront a minor palate
Thou could'st not goad so long —

I tell thee while I waited —
The mystery of Food
Increased till I abjured it
Subsisting now like God —

<div align="right">

—Emily Dickinson

</div>

In Yeats's play *The King's Threshold,* the legendary Irish poet Seanchan fasts on the doorstep of the King because he has been banished from his table. The men of action at the court, the "Bishops, Soldiers, and Makers of the Law," resent the fact that "a mere man of words" should sit among them at the highest table of the land.[1] Seanchan, however, pleads the ancient right of poets, "established at the establishment of the world," to dine at the table of the King (109). He fasts, therefore, in order to regain his seat and to vindicate the sanctity and precedence of poetry.

Yeats's play resembles Kafka's story of "The Hunger Artist" in that both these parables imply that the artist has to starve in order to perfect the work of art. Seanchan famishes his body to defend his words, while the hunger artist turns his very flesh into a self-consuming artifact. Both, however, hunger for the sake of an implacable aesthetic that demands the decreation of the flesh. This chapter, through a comparison of Yeats's and Kafka's hunger artists and an exploration

of *Clarissa* and the Irish Hunger Strike, attempts to trace the strategies by which the flesh is transfigured into words, because the art of disembodiment depends upon this fatal alchemy.

Yeats claimed that when he wrote *The King's Threshold* "neither suffragette nor patriot had adopted the hunger strike, nor had the hunger strike been used anywhere, so far as I know, as a political weapon."[2] Hence he took some satisfaction in his prescience when the hunger strike began to dominate the nationalist cause to which he had aligned himself in the intervening years. In truth, it was his play that was transformed by Irish politics, rather than the other way around: Yeats revised *The King's Threshold* after the death in 1920 of one of the most famous hunger strikers of the Republican movement, Terence Mac-Swiney, Lord Mayor of Cork, who died in Brixton Prison after seventy-four days without food. MacSwiney bequeathed his lethal philosophy of self-denial to the cause of nationalism, and in particular the often-quoted formula "It is not those who can inflict the most, but those who can suffer the most who will conquer."[3] This was the slogan that the hunger strikers of Long Kesh invoked in 1981 to justify their serial suicides. And it was probably to vindicate MacSwiney's ethic of self-sacrifice that Yeats decided to recast the ending of his play: in the 1904 version of the work, Seanchan survives his ordeal, whereas in the 1922 edition he starves to death.[4]

Nonetheless, *The King's Threshold* sets out to prove that poetry directs the course of politics, because the world of power is the product of the poet's dreams. Seanchan would affirm with Shelley that the poets are the unacknowledged legislators of mankind: for it was they who first invented the ideas of sovereignty, rank, and law, and thus instated precedence amidst the brute democracy of nature. The King himself, who deprecates the bards, owes his very title and dominion to their metaphors. "The King's money would not buy," Seanchan declares,

> Nor the high circle consecrate his head,
> If poets had never christened gold, and even

THE HUNGER ARTISTS

The moon's poor daughter, that most whey-faced metal
Precious . . . (127)

In other words, it was the poets who invested gold and silver with
their luster and consecrated the high circle of the crown, because the
magic of these objects was created by the bards' enraptured meta-
phors. But Seanchan also makes the bolder claim that poetry is literally
"midwife to society," and appeals to eugenics in a desperate attempt
to justify the privileges of his trade. Good poetry produces better bod-
ies, he proclaims, and therefore mothers must be careful to avoid bad
poets lest their children be disfigured in the womb.[5] (Of all the advice
doled out to pregnant women, this is probably the weirdest yet.) "But
why were you born crooked?" Seanchan demands of the cripples who
entreat him to conclude his fast. "What bad poet did your mothers
listen to / That you were born so crooked?" (133). According to this
logic, the arts must be respected if the racial stock is to be saved. "If
the Arts should perish," Seanchan's disciple prophesies:

The world that lacked them would be like a woman
That looking on the cloven lips of a hare,
Brings forth a hare-lipped child. (112)

When poetry regains its ancient honors, a nobler race of beings will
be born, who are described as ominously Aryan: "that great race / That
would be haughty, mirthful, and white-bodied . . . " (135). In this
economy, the poet has to starve his flesh to feed the words that fatten
the descendants of his readers, in order to redeem the bodies of post-
erity.

Wacky as it is, this theory touches on the central polarity of
Yeats's thought, between the world of action and the world of words.
Indeed, the "threshold" of the play could be interpreted as the sym-
bolic borderline where poetry and power, imagination and reality, lan-
guage and the body coincide. And Yeats's poems constitute a history
of his body: a body that insists on being written even if it must be
"bruised to pleasure soul" and eviscerated by the labour of its self-
creation. That is why the poets must be thin, because they sacrifice

their flesh for words, ravaged by the body-sapping discipline of metaphor. The poet in "Sailing to Byzantium" is reduced to skin and bones, scarcely bodily enough to hang a coat upon: "An aged man is but a paltry thing / A tattered coat upon a stick."[6] And Yeats's wild old wicked men, for all their lust and rage, are never fat. Yet it is crucial that Yeats does not describe old age as a transcendence of the body but rather as the ultimate immersion in its anguish. Bodily decrepitude is wisdom—not because it liberates the spirit but because it fastens the imagination to the flesh. The Ledaean body, drunk with the bitter sweetness of its youth, is blissfully unconscious of itself; only the arthritic body, racked with the memories of starved desires, can apprehend the truth of its carnality. Embarrassment, not rapture, is the route to enlightenment in Yeats: for it is when the body has begun to fail that it asserts its claims upon the spirit, and the mind is forced to know itself as body, ridiculous in its obtuse corporeality, a scarecrow or a smiling public man.[7]

Seanchan, as a fasting writer, gives literal expression to the view that writing devastates the body, thins it out and sucks it dry. For Yeats sees hunger as the food of poetry, just as he sees frustration as the food of love. In "Ego Dominus Tuus," he suggests that Dante's art was inspired by a "hunger for the apple on the bough / Most out of reach." His face grew "hollow" in his Tantalean quest to find a bread too bitter to be eaten and a lady too exalted to be loved. Hic, the first of the two speakers, claims that Dante:

> so utterly found himself
> That he has made that hollow face of his
> More plain to the mind's eye than any face
> But that of Christ.

But Ille, Yeats's spokesman, disagrees. It was not *himself* that Dante found—not "The man that Lapo and that Guido knew"—but an image "fashioned from his opposite," an anti-self. He hollowed out his body in order to call forth this unknown self and to incarnate all that he had "handled least, least looked upon," in a body of words.

THE HUNGER ARTISTS

He set his chisel to the hardest stone.
Being mocked by Guido for his lecherous life,
Derided and deriding, driven out
To climb that stair and eat that bitter bread,
He found the unpersuadable justice, he found
The most exalted lady loved by a man.[8]

In his essay *Per Amica Silentia Lunae,* Yeats writes that "the passions, when . . . they cannot find fulfilment, become vision." In other words, the visions of the poets, like the dreams of love, thrive on the starvation of the appetites. This is because "the desire that is satisfied is not a great desire," and even "fulfilled desire" is nothing but a "hollow image." In this aesthetic, imagination has become the overdraft, rather than the overflow, of powerful feeling, the sumptuous destitution of the heart. For it is only "when I understand that I have nothing," Yeats declares, that "I shall find the dark grow luminous, the void fruitful."[9] The poet has to sacrifice his flesh to purify the dialect, which is the only way to purify the tribe.

René Girard, in his analysis of sacrifice, has argued that the scapegoat functions as a surrogate for the community, which vents its violence upon this victim in order to maintain its perilous cohesion. The classical literature of China stresses this unifying function: "It is through the sacrifices that the unity of the people is strengthened."[10] *The King's Threshold,* however, illustrates what Girard calls "the sacrificial crisis," in which the "gap between the individual and the community" grows too large for the victim to act as the "conductor" of the group's internal fury.[11] For Seanchan fails to *represent* the people he professes to be saving. If the power of a hunger strike depends upon the substitution of the individual for the community, Seanchan has to resort to physical coercion in order to assume the role of surrogate. He seizes the hand of his sweetheart, Fedelm, and uses it to push away the food that has been offered to him by the King. "You have refused, Seanchan," the King remonstrates. No, says Seanchan. "*We* have refused it" (140: my emphasis). This forced "we" seems to mock the

very notion of community. Yet its awkwardness reveals the difficulties facing Yeats as an Anglo-Irish Protestant attempting to be spokesman for his people and to forge the uncreated conscience of his race. His discomfort in the role asserts itself in all the solecisms of the play in spite of his attempts to overwhelm it with mellifluence. Seanchan, Yeats's mouthpiece, cannot capture the imagination of his people or make his sufferings the emblem of their own. This is painfully apparent when the mayor from Seanchan's childhood home arrives to warn him that the King will starve the people if Seanchan continues with his fast. He does persist, however, for if poets cannot dine with kings he thinks it is iniquitous for anyone to eat at all. Not surprisingly, the mayor finds this logic hard to stomach. And the mayor's threat of mass starvation gives expression to the terrifying guilt of a poet deracinated from his nation and secretly at odds against the silent masses for whom he claims to speak. Although Seanchan insists that he is starving for the nation, this episode suggests that he would rather the nation starve for him; and the poetry implies that he is sloughing off the weight of nationalism, leaving his imagination stateless, free to soar:

For when the heavy body has grown weak,
There's nothing that can tether the wild mind
That being moonstruck and fantastical,
Goes where it fancies. (111)

Seanchan's hunger strike resembles Yeats's mysticism in that it transports the poet to a higher plane, where he escapes the land and all its unavenged afflictions. The failure of the play, however, shows that nationhood cannot be starved or dreamed away. For failure it is. It would take a Yeats to transform Seanchan's injured vanity into a noble cause, but in this case even the master of such metamorphoses fails to discover the terrible beauty of this sulky bard. Yeats himself admitted that he could not tell if the play was meant to be a tragedy or a farce: and his indecision is more eloquent than his solutions. For

The King's Threshold shows an artist so marooned from his community that he no longer even knows what he is hungry for.

Kafka's "A Hunger Artist" also explores this "sacrificial crisis," but it reveals the ever-widening abyss between the polis and its ravaged surrogates.[12] In Kafka's story, the community rejects the victim who hungers for its sake, bored by his display of self-denial. In the old days, Kafka tells us, when the hunger artist was in fashion, the excitement of the public would increase with every hour of his abstinence. Besides casual onlookers there were full-time watchers, usually butchers, who were meant to keep him under continual surveillance in case he should be eating on the sly. Of course, the honor of his art forbade him from swallowing the smallest morsel; but the suspicions of the public were a "necessary accompaniment" to his performance, since it kept their eyes transfixed on his disintegrating frame (269).

No one, though, could monitor his fast uninterruptedly, and for this reason the hunger artist was condemned to be "the sole completely satisfied" spectator of his own starvation (270). Yet there were reasons why he never *was* quite satisfied. In visible glory, honored by the world, he alone knew that it was all too easy not to eat, though no one would believe him when he told them so. Besides, his impresario had limited his fasts to forty days, reckoning that public interest would flag if the performance were prolonged. Thus the hunger artist was never able to display his virtuosity to the full. On the fortieth day the flower-bedecked cage would be opened, and the starveling would be led by two young maidens to a table laden with the meagre invalid's repast that marked his passage back into the world.

At the time of the story, though, "interest in professional fasting has markedly diminished," and the hunger artist has been forced into a quiet corner of a circus (268). Here he undertakes his most ambitious fast of all. However, the spectators scarcely glance at him as they stream past his cage towards the meatier thrills of the menagerie. At length the hunger artist is forgotten even by the management, but he fasts on and on as he had once dreamed of doing, losing track of the

days that he has starved and of the records he has broken. One day an overseer passing by his cage asks the guards why it is standing empty and unused. Mystified, they poke the dirty straw and discover the famished remnants of the hunger artist. He has just enough strength to whisper his last words into the overseer's ear, and pursing his lips as if for a kiss, he confesses that the only reason that he starved was that he never found the food he liked to eat: "If I had found it, believe me, I should have made no fuss and stuffed myself like you or anyone else," he says (277). After he is dead and buried, straw and all, the attendants place a young panther in his cage. The crowds who had ignored the hunger artist now stand mesmerized by the vigor of this noble beast, stuffed almost to bursting with the food it likes.

What does this story mean? Kafka once said, "Metaphors are one of the things that make me despair of literature"; and it is important therefore to respect the letter of the text, to honor its *semantic* abstinence.[13] As the hunger artist starves his flesh, so Kafka emaciates his prose, supplanting the fat novel of the nineteenth century with the skeletal apparatus of a writing machine. At one level the story can be taken literally, because there actually were some famous hunger artists whose fortunes peaked in the last decade of the nineteenth century, and who persisted in their strange performances until their "art" went out of vogue in World War I.[14] In any case, Kafka thins out the allusive and associative fabric of the story until it is very difficult to treat it as a metaphor for something else, or for some rich and hidden amplitude of meaning. Vestiges of old mythologies resurface in the text only to be stripped of resonance. For instance, the hunger artist starves for forty days, just as Christ fasted in the wilderness, and just as Moses fasted on Mount Sinai while he waited for the Ten Commandments, forfeiting his flesh in order to receive the word of God.[15] What is more, the hunger artist seems to take the role of sacrificial surrogate, who immolates himself to unify his race: the public celebrations that conclude his fast reunite the scattered populace, overcoming its internal strife. Yet the story intimates that sacrifice has been reduced to show business, since the hunger artist is a stuntman rather than a saint, and the role of priest has been supplanted by the impresario. There is no

THE HUNGER ARTISTS

sin in Kafka's world and hence no absolution, only the ruins of exhausted cults to trouble the banality of innocence.

It is evident, however, that the power of starvation depends upon its visibility, and for this reason images of light and sight pervade Kafka's prose.[16] If the presence of spectators dignifies the fast into an art, their absence reduces it to a pathology.[17] The story seems to confirm Horkheimer and Adorno's view that "the history of civilisation is the history of the introversion of the sacrifice," insofar as fasting, which was once a sacrifice performed on behalf of the community, has now been "introverted" into individual neurosis.[18] Public ritual is transformed into private compulsion: "You shouldn't admire it," the wraith gasps at the end, "I can't help it" (277). The panther who supplants the hunger artist seems to symbolize the revolution in the concept of the flesh, whereby the holy mystery of suffering has been effaced in favor of the secular idolatry of health, which has tyrannized the modern age from Aryan mythology to bodybuilding. In a culture of butchers, entranced by youth, scornful of mortification, there is no sanctity in the privations of the flesh; and Kafka's story shows how suffering has been been progressively desacralized, desocialized, and starved of sense.

The theme of hunger constantly resurfaces in Kafka's texts, and it is embroiled in the equally obsessive theme of writing. Deleuze and Guattari go so far as to contend that Kafka's entire corpus constitutes "a long history of fasts."[19] For example, Gregor Samsa wakes up in "The Metamorphosis" to find himself transformed into a gigantic bug, and his first sensation is rapacity: "Gregor's legs all whizzed towards the food" (108). But soon he too becomes a hunger artist who starves because he cannot find a food he likes to eat, baffled by his body and its alien desires:

> It seemed remarkable to Gregor that among the various
> noises coming from the table he could always distinguish
> the sound of their masticating teeth, as if this were a sign
> to Gregor that one needed teeth in order to eat, and that
> with toothless jaws even of the finest make one could do

nothing. "I'm hungry enough," said Gregor sadly to himself, "but not for that kind of food. How these lodgers are stuffing themselves, and here am I dying of starvation!" (129)

Kafka's story "The Investigations of a Dog," also revolves around the mystery of food. "For penetrating into real dog nature, research into food seemed to me the best method, calculated to lead me to my goal by the straightest path," the canine sleuth declares (315). This is because dogs are notorious for their insatiable greed (in fact, the term "bulimia" is defined by the *Oxford English Dictionary* as "canine hunger").[20] Kafka's dog, however, is hungrier for knowledge than for food; and in the world of dogdom, food-for-flesh and food-for-thought are associated with the earth and air respectively. Earthbound dogs are so preoccupied with eating that they scarcely bring themselves to speak at all; but there is another race of "soaring dogs," who divert attention from their airborne state by means of "an almost unendurable volubility" (293, 295). These lightweight intellectuals surfeit with the words of which the laborers below have been deprived: it seems that dogs who live on words can fly, while dogs who live on food are doomed to gravity and elocutionary famine. In any case, the world of speech is incompatible with that of ingustation. This is why the hero of the story imagines that his fellow dogs would like to stop his mouth with food to throttle his insatiable questions. Because questions issue from the same orifice in which nutrition is imbibed, the dog eventually renounces food for questions and consummates his research with a fast. Fasting is "the highest effort possible among dogs," and hence "the final and most potent means" of his investigations. "The way goes through fasting," he declares (308).

When the dog has nearly starved to death to satisfy his craving for enlightenment, he is rescued by a passing hound, who sings him back to life. This song is so entrancing that the hero resolves to penetrate its secrets and abandon the study of food for the study of music. This incident recalls an earlier event, when the investigator as a puppy had encountered seven dogs who conjured music from the empty air

　　　　　　　　　THE HUNGER ARTISTS

without so much as opening their mouths. "They did not speak, they did not sing," he says, but music rained from everywhere, maddening the listener (281). The same kind of music saves him in the end, a song without words and even without flesh, since the dog who revives him is singing "without knowing it." The melody, "separated from him, was floating on the air in accordance with its own laws, and the worst was that it seemed to exist solely for my sake, this voice before whose sublimity the woods fell silent." (314). This experience persuades the dog to carry his investigations into music, or rather into the "border region" where food and music interpenetrate, where the sciences of nourishment and incantation are united (315). The story ends with all his questions burning.

According to Aquinas, angels were invisible except when they assumed the power of speech, for speech necessitates a body.[21] Kafka reverses this theology, for he associates the art of song with *disembodiment*. In "The Investigations of a Dog," song corresponds more closely to writing than to speech, insofar as it is severed from the flesh. This image of the voice-without-a-body recurs in Kafka's other works: in "The Burrow," for example, the narrator's hermetic isolation is destroyed by an unearthly whistling whose origin cannot be localized. Similarly, the hunger artist's only quoted speech, his last confession, breaks from his lips when he is all but disenfleshed. And the noises that escape from Gregor Samsa's mouth when he attempts to speak bear no relation to his human consciousness: "That was no human voice," the chief clerk falters, terrified (98). In all these cases speech entails a terrifying dislocation from the body, whereby the voice is either *dis-* or *mis*carnated. And if speech embrutes the body, writing eviscerates the flesh; as in Kafka's "Penal Colony," where the condemned are literally disemboweled by the "sentences" impaled into their entrails.

Yeats and Kafka both suggest that the creation of the work of art demands the deconstruction of the body. At the same time, though, their writings demonstrate the impotence of self-starvation, its obsolescence

as a rite of expiation. The image of the starving artist in their work seems to stand for the crisis of high art in bourgeois culture; that is, for the exclusion of artists from the life of commerce and their proud refusal to be "fed" by capital. In "The Hunger Artist," for example, the indifference of the townspeople to hunger testifies to their indifference to art, and also indicates the severance between the modern artist and the masses. Peter Bürger has argued that the ideology of artistic autonomy, which resulted from the isolation of the artist from the marketplace, led to a feeling of impotence among writers and to a realization of the social *ineffectiveness* of their own medium.[22] In Yeats and Kafka, *autonomy* is represented as *autophagy*, because their starving artists eat *themselves* in the absence of any nourishment from their societies.[23] Cut off from verbal, alimentary, and economic interchange with others, the artist's hunger has become inevitable but ridiculous, because it is impossible to make the world appreciate his sufferings. The people can no longer recognize his lack as the image of their own.

The next section compares Clarissa's self-starvation to the Irish Hunger Strike, focusing on the conversion of the body into words. For it is not so much the common theme of hunger that links the hunger strikers of Long Kesh to Richardson's ascetic heroine as the complicity between starvation and garrulity. The bodies of the starvers dwindle as their texts expand, as if they were devoured by their prose. Since food and words are circulating currencies, the faster, by refusing one such form of interchange, seems to be impelled to look for satisfaction in the other. It is *circulation,* therefore, that underlies the art of hunger, and it is necessary to investigate this ruinous economy.

> *Now wilt thou see all my circulation: as in a glass wilt thou see it.*
>
> —Lovelace to Belford, *Clarissa*

In 1975 the British government abolished detention without trial for Republican terrorists in Northern Ireland. At the same time, however, it phased in a new "criminalization" policy, meaning that political pris-

THE HUNGER ARTISTS

oners were to be treated as "common" criminals, rather than as prisoners of war. A stream of propaganda issued forth from politicians and police commanders, denouncing the leaders of the IRA as "godfathers," their groups as "gangs," their men as "thugs." Inside the H-Blocks of Long Kesh, the principal detention camp, political prisoners, forbidden to wear their own clothes, chose to wear no clothes at all rather than adopt the prison uniform, which obliterated the distinction between crime and war.[24] Instead, they draped themselves in blankets. The "blanket protest" was soon followed by the "no-wash protest," in which the prisoners refused to use the washroom because it would oblige them to expose their nakedness. After much brutality from warders, mostly Protestant and known as "screws," the prisoners retaliated with the "dirty protest," smearing their well-appointed cells with food and excrement and pouring urine through the doors.[25] When even "the battle of the bowels" proved ineffectual, however, the Hunger Strike of 1981 began. It did not end until ten men had left the H-Blocks in their coffins.

On the face of it, the real sufferings of ten Irish Republicans have little in common with the fictive tribulations that Richardson devised for his unhappy heroine. Bobby Sands and Clarissa Harlowe make an unlikely pair. Yet even the disparities between them are crucial to their strange confederacy. A historian in 1802 described the recent Act of Union between Ireland and England as a "brutal rape," and Ireland as an heiress whose chambermaid and trustees had been bribed while she herself was dragged, protesting, to the altar.[26] He might well have been alluding to *Clarissa,* because the novel was so famous that the heroine's distress had become a byword for exploitation. Clarissa, too, escapes from a forced marriage only to be raped by the man who promised to protect her. Moreover, she protests against her fate by going on a hunger strike, and dies before she can enjoy the concessions that her sufferings have won.

John Berger in his book *Ways of Seeing* has argued that "*men act and women appear.*"[27] If this is true, the prisoners in Northern Ireland were feminized by their starvation in that their bodies were transformed into the images of meanings rather than the instruments of

acts. Yet hunger also brings to light the fierce dissymmetries between the sexes. For the men imprisoned in the Kesh, hunger was a public and concerted enterprise, the corporeal expression of their five demands for special status as prisoners of war.[28] In their case word and flesh supported one another, parallel and complementary, because it was their verbal protest that conferred their wasting bodies with their eloquence.

While the IRA starved publicly and clamorously, Clarissa, like the modern anorectic, starves in private; and although she indulges her taste for words as vigorously as she stints her taste for food, she never articulates the reasons for her hunger. Indeed, her body's protest wildly exceeds her speech, racked with meanings too ferocious to enunciate. Word and flesh consume each other in her long and complicated death, her inexorable quest for discarnation. By disembodying herself, she refuses even the somatic language of hysteria, where words that cannot surface in the form of speech find expression in the form of symptoms. For Clarissa wants to shut her body up, in every sense; and it is only in the coffin that its vengeful ambiguities can be contained. In Long Kesh, hunger had a fixed, contractual significance, even if the world misunderstood it, and even if its resonance exceeded the declared intentions of the protesters. But Clarissa cannot read her own starvation. Devouring meanings in default of food, her body has become too dense, too contradictory a sign.

To compare Clarissa's fictional starvation to the struggles of Long Kesh is not therefore to disavow the harrowing realities of Irish politics. In the first place, the war in Northern Ireland is being waged with words as well as blood, which is why Liz Curtis, for example, has described it as a "propaganda war."[29] The reason that the Irish Hunger Strike succeeded where other forms of protest often fail was due to its dramatic power rather than its mortal toll. It was not by hungering as such, but by making theater of their own starvation, that the prisoners brought shame on their oppressors and captured the sympathies of their co-religionists. The more the body's flesh decayed, the more its rhetoricity appeared, until its being was extinguished in meaning. But Clarissa's body speaks a different idiolect: and by contrasting the

fraternal hunger of the H-Blocks to the lonely labor of her disembodiment, a grammar of starvation will unfold.

"And is this all!—is it all of my CLARISSA's Story!" (1402).[30] This is what Anna Howe, Clarissa's confidant, exclaims when she confronts Clarissa's body in its coffin in the final pages of the novel. It is a peculiar epitaph to such a lengthy and exhaustive text, since it suggests that Clarissa's story is aborted rather than concluded, and that the heroine has died before she had a chance to come to life. After so many hundreds of pages of prolixity the novel leaves the reader stranded with the mystery of the unsaid and the unborn. Whatever happened to Clarissa's story? "One is never sure," as Terry Castle says, because Richardson's "lurching, exhausting text, with its mysterious lesions and effusions," challenges the very principles of a coherent narrative.[31] For every stratagem that comes to fruition a dozen others are stillborn, and any précis of the text obscures these foiled plots and broken dreams. At one stage Lovelace fantasizes that Clarissa is to bear him twin sons, but these children are never really born, because although Clarissa is indeed in labor for the final volumes of the novel, she is giving birth to death rather than life. These undelivered children, like her misdelivered mail, seem to stand for all the novel's unachievable scenarios. Unfeeding and unbreeding, Clarissa's body represents the hungry core of this fat book, the dearth that nourishes its strange fecundity.

At the beginning of the novel, Clarissa is warring with her family, who are desperate to increase their newfound riches by marrying her off to a rich husband. Having been a favored child, she dates her downfall to the fortune that her doting grandfather bequeathed to her, because it has inflamed the wrath of her less favored siblings: "the enviable estate which has been the original cause of all my misfortunes" (754). Meanwhile Lovelace, the libertine aristocrat, is making advances to Clarissa, and although he has the birth and money to recommend himself to her aspiring family he has already aroused the envy of her brother James by besting him at swords. Determined to thwart Love-

lace's suit, James digs up a wealthy rival for Clarissa's hand in the grue-
some form of Mr. Solmes. Obese and depraved, Solmes's truly unfor-
givable defect is that he writes abominable letters: for in this novel
bourgeois greed deforms both flesh and word, producing swelling in
the one, misspelling in the other. James persuades his family to force
Clarissa into this odious marriage, in order to frustrate the dashing
Lovelace and to punish his sister for her legacy and her intolerable
loveliness.

To this end Clarissa is imprisoned in her room and forbidden
even to write letters, although she manages to circumvent this pro-
hibition with a secret store of writing implements and an intrepid
maid. The more her family pushes her towards Solmes, however, the
more she is obliged to seek protection from the man who is destined
to destroy her. Many readers of the novel—particularly male read-
ers—have been seduced by Lovelace's mercurial wit, but Clarissa
stubbornly resists his charms. On the contrary, she fears him; yet she
allows herself to be drawn into his web in order to escape her family's
pitiless coercion. After luring her into a "forbidden correspondence"
(393), he tricks her into running off with him by threatening violence
against her family. He hides her in a house in London, "a back house
within a front one," which in mockery of its respectable façade turns
out to be a brothel (491). It is managed by a whoremistress called Sin-
clair: no Christian name, no title. The house is well secured with
bolts and locks, which Clarissa uses to protect her honor as Lovelace's
advances escalate. Soon, however, it is he who locks her up, as her
father had before, and woos her with a kind of military ingenuity.
When her virtue proves impregnable, he rapes her. After a period of
delirium, she finally manages to escape, pursued by Lovelace's minions,
who mastermind her final degradation: she is arrested on the street
for trumped-up debts she is supposed to owe to Sinclair for her room
and board. On this pretext she is incarcerated yet again, this time un-
der the aegis of the law and in the premises of a policeman known as
Rowland. But Lovelace's confidant and correspondent, Belford, who
has been privy to Clarissa's tribulations all along, finds this false arrest
so monstrous that he finally renounces rakedom and releases her from

THE HUNGER ARTISTS

Rowland's jail. From this point on, Lovelace's compulsion to seduce is overshadowed by Clarissa's equally resourceful drive to die. To this purpose she systematically refuses food, and Richardson enumerates each of her uneaten meals with his habitual exhaustiveness. Clarissa, similarly, leaves no detail of her death to chance. She even purchases her coffin, decorates it with her own conundra, and writes her anguished letters on its lid. Yet in spite of her heart-wringing pleas, her family's letters of forgiveness come too late, and Clarissa dies dishonored, cursed, and dispossessed. Her death is followed by a long and complicated will, in which the heroine dispenses virtuous reflections as liberally as her worldly goods. She also pleads that there should be no vengeance for her injuries. Nonetheless her cousin Morden pursues the unrepentant Lovelace and at last acquits her rape with the rapier that he plunges in the heart of her defiler (1485–1488). It seems that all the wrongs of woman in the text prepare the way for this male rape, this final penetration.

But these events form only one part of Clarissa's story. The other, and the most important, part consists of the epistolary intercourse that both describes and reenacts her sexual catastrophe. The narrative revolves around the misadventures of the post, which mirror the misfortunes of the heroine: her letters, like her person, circulate from man to man, perpetually misaddressed and misconstrued. Just as her letters are enclosed in other people's envelopes, so her body is immured in other people's walls: and worse, her body is intercepted like her letters, its seal invaded and its message forged.

Clarissa's father is the linchpin of the text's economies, since it is he who oversees the sexual, linguistic, and financial circulation that interweaves the agents of her nemesis. Yet although he presides over the traffic in women, money, and missives, he remains aloof from their commotion. Neither writing nor receiving letters, he rarely appears except in his deputed forms, and his authority devolves among a host of human and epistolary delegates. In this sense he represents the void at the source of all epistolary interchange, since letters depend for their existence on the absence that divides the sender from the addressee. It is his name which rules the family rather than his presence, and that

name serves to mask a much more complicated system of repression than the "absoluteness" that Clarissa attributes to the fetish of paternity. Indeed, the novel hints that it is not the father who destroys Clarissa so much as the absence of an ultimate authority to guarantee the morals or the meanings of her world: as she puts it, "Nothing less than the intervention of paternal authority . . . could have saved me" (989).

For Richardson presents a world in which all subjects are enmeshed in networks of exchange that exceed their consciousness and agency. What controls the actors' fates is the circulation of the post, as opposed to any merely human power. And just as letters go astray, so the characters' intentions go awry, distorting the consequences of their words and deeds. (As Hamlet puts it, in a play obsessed with the caprices of the post: "Our thoughts are ours, their ends, none of our own.") The Harlowes, for example, think that Lovelace is their enemy, yet the novel hints that they are deeply in collusion, for Lovelace often boasts that Clarissa's family is unwittingly conspiring on his behalf: "her father stormed as I directed him to storm" (517). But Clarissa is closer to the mark when she discerns that Lovelace is the vehicle of her paternal malediction, the "very letter" of her father's law: "My father's dreadful curse has already operated on me in the very *letter* of it as to this life" (899: my emphasis). For the father has condemned her to meet her punishment, "both *here* and *hereafter,* by means of the very wretch in whom you have chosen to place your wicked confidence" (509). Lovelace represents the "letter" of the law, to use Clarissa's word, in that he fulfills her father's sentence *to the letter,* killing Clarissa as the letter traditionally kills. He increasingly adopts the father's role, first by imprisoning Clarissa and later by prohibiting her correspondence, until it is hard to tell the despot from the saboteur.

Lovelace even calls himself a father, or more specifically a "name-father" (569), since he bestows Clarissa with another name every time he moves her to a new address. Under his power, the proper name ceases to stand for what is proper to the self and comes to represent a counterforce of dispossession. By assuming the paternal prerogative to name, Lovelace is attempting to appropriate the post, to take over

the system of names and addresses that assigns each subject to a destined place: "The post, general and penny, will be strictly watched," he declares (817). This is one reason why he sees himself as Mercury, the god of mail (551). But Mercury was also god of thieves; and Lovelace, too, combines these roles, because he robs Clarissa's letters just as he appropriates her flesh; indeed, the verb "to rape" originally meant "to steal."[32]

Lacan, in his essay on "The Purloined Letter," poses the question "To whom does a letter belong?"[33] Of course, it is impossible to prove that letters belong by right either to their senders or their addressees. In this sense the post *is* theft, and letters, in essence, are purloined. In *Clarissa,* Lacan's question could be asked of the heroine herself: to whom does a woman belong? "I am nobody's," she mourns—not even her own (1413). From the moment that she allows the fatal letter "out of [her] power" and agrees to rendezvous with Lovelace in the garden, her body too slips out of her control (343). For this letter leads to her abduction, after which she too becomes a letter, ownerless and irreclaimable. "My life is in my own power, though my person is not," she cries much later in the novel, brandishing a penknife at her breast (938); and yet she cannot even opt for suicide because she is God's creature, "and not my own" (341). Fatherless and husbandless, she cannot even claim a proper name: "I don't know what my name is!" she despairs (890). Lovelace seizes this advantage: "And whose property, I pray thee, shall I invade, if I pursue my schemes of love and vengeance?" (717). For Lovelace, Clarissa's escape would be "the greatest of felonies," because "she would have stolen herself" (757). "Whose was she living?" he demands. "Whose is she dead, but mine?" (1384). Starving is Clarissa's last attempt to be the author of herself, for this is when she finally regains her name, but only when she is encoffined in her signature.[34] What's in a name? The answer to this question in *Clarissa,* as in its source in *Romeo and Juliet,* is death.

Lovelace abducts Clarissa's name long before he violates her person, and the onomastic rape seems to necessitate the carnal defloration. For there is a strange and dreamlike logic in this text that dictates that words become deeds and that whatever is enunciated be enacted.

Thus the characters are ambushed by the unintended meanings of their words, which confront them in the guise of flesh and blood. For instance, when Clarissa repents "the sin of a prohibited correspondence" (165), she is ostensibly referring to her letters, but the rape gives this epistolary intercourse its carnal form, embruting its transgressive words with savage flesh. The phrase "prohibited correspondence" also suggests a violation of semantics, of the proper correspondence between sign and sense. For Lovelace lures the heroine into a wilderness where words and meanings, like names and addresses, liaise according to his whim. Indeed, Clarissa is at least as shocked by his semantic as by his erotic improprieties. Yet even though he claims to make words mean whatever he desires, it is only women who suffer his linguistic rakedom. Many critics like to see him as a deconstructionist *avant la lettre*, but Lovelace never really challenges the rules of reference. On the contrary he bends these rules with women only so that he may reinforce his bonds with men. As Colonel Morden observes, "'Tis, really, a strange liberty gentlemen of free principles take; who at the same time that they would resent unto death the imputation of being capable of telling an untruth to a man, will not scruple to break through the most solemn oaths and promises to a woman" (1283). The lies that Lovelace tells to women have become the measure of the truth he tells to men. Women must lose their honor, their virginity, for men to gain their honor, their veracity: and the word of a gentleman thus depends upon the subjugation of a woman's flesh.

This is why Lovelace's correspondence with his friends revolves obsessively around the molestation of the heroine. Clarissa has to be dishonored in order to sustain the discourse between men and to cement their homosocial bonds.[35] Lovelace often encloses Clarissa's letters in his own for Belford's delectation; and in this way he makes her play the go-between in his liaison with his fellow rake. In fact, Lovelace more or less admits that his seduction of Clarissa is merely a pretext for exchanging letters with his male conspirators. When Clarissa escapes after the rape, it is not her company he mourns, but the fact that he has "lost the only subject worth writing upon" (1023). This phrase reveals that his ruling passion is the writing, rather than the

　　　　　　　　　　THE HUNGER ARTISTS

act, of love. Elsewhere he asks, "What, as I have often contemplated, is the enjoyment of the finest woman in the world, to the contrivance, the bustle, the surprises, and at last the happy conclusion of a well-laid plot?" (920). Here the term "plot" could refer to his *narration* of events as well as to the escapades that he recounts. And writing is so deeply implicated in desire in this text that it constitutes a vice in its own right. Lovelace composes his epistles with all the fervor and the secrecy of a perversion. In a passage famous for its double entendres, Anna Howe informs Clarissa that Lovelace is "notoriously, nay, avowedly, a man of pleasure . . . He rests, it seems, not above six hours in the twenty-four—any more than you. He delights in writing . . . he has always a pen in his fingers when he retires . . . his thoughts flow rapidly to his pen" (74). *"Thou gloriest in thy pen,"* Clarissa scolds him (1174).[36] Thus Lovelace's assault upon Clarissa's virtue serves mainly as a pretext for the onanistic pleasures of his "pen." When he finally rapes her it is out of spite rather than lust, and he finds himself frustrated and bewildered, because he has betrayed the logic of his own libido, which is to substitute the letter for the flesh. This novel reverses the Freudian convention that writing is the sublimation of desire, because Lovelace turns to sex only as a substitute for letters, a poor and disappointing substitute at that. When he finally resorts to rape it is in order to relieve his graphomania, his fatal avidity for ink, for he has lost "the only subject worth writing upon." Since Clarissa has deprived him of his words, he is forced to make his imprint on her flesh, substituting violence for the letter.

At this point it is Clarissa who assumes the task of turning flesh back into words. This she accomplishes by starving, for in her death she accedes to the condition of the letter, enveloping herself into the coffin of her script. However, her abstinence begins much earlier, when she is banished from the family table and imprisoned in her own paternal home. Unlike Miss Havisham, another literary anorectic, who nibbles during her noctambulations, or the modern-day bulimic on a midnight raid, Clarissa likes to dine in company. Forced into seclusion, she re-

stricts herself to Lenten fare. David Herlihy has defined the family as a group of people who eat together; and since Clarissa sees the world as "one great family," her starvation seems to represent a flight from humankind.[37] When Lovelace offends her, Clarissa cries, "I cannot eat" because "I cannot sit down at table with him!" (798). If the dinner table represents the social contract, it also represents the world of speech. After her banishment Clarissa writes because she has been forced to "lock up her speech" (879). Unable to communicate directly with her torturers, her letters take the place of voice and food at once.

"For what purpose should I eat?" she cries. "I will neither eat nor drink" (895). By refusing to eat, she is also refusing to *be* eaten, to sacrifice her body to her family's greed. "Daughters are chickens brought up for the tables of other men" (77), James Harlowe sniggers at one point, while Mr. Solmes is ogling Clarissa hungrily; and Lovelace, too, is later branded as a "woman-eater" (1216). Though her family tries to reassure her, saying, "Mr. Solmes will neither eat you, nor drink you" (267), these images sow the suspicion in the text that marriage is a euphemism for gynophagy. Thus it is significant that the men responsible for the destruction of Clarissa suffer from severe dyspepsia, as if they were unable to digest the female flesh that they devour. If Clarissa is anorectic, her father is bulimic, choking on the spoils of his greed, "his extraordinary prosperity but adding to his impatience" (55). His spasms, like his prohibitions, spread infectiously around the text, somatic symptoms of the devolution of his power. The "over-boiling tumults" of Clarissa's brother are a good example (1163). Similarly, Lovelace's stomach is as turbulent as his epistolary style, with "fits and starts, and sallies," "half-choking flutters," and "involuntary commotions" (458, 520). It is through a self-induced attack of vomiting that he tricks Clarissa into tenderness, and the genital convulsions of the rape are foreshadowed in this gastric orgasm (673-679). Even his last words—"Let this expiate!"—burst forth from his lips in "a seeming ejaculation" (1488). But it is Sinclair, even more that Lovelace, who usurps the father's role, for she is only masquerading as a man, and her bawdy-house of women travesties the Harlowes' house of

THE HUNGER ARTISTS

men. Like Harlowe, Sinclair feeds upon the sale of women's bodies, growing fatter as Clarissa wastes away. While her fat becomes the phobic image of sexual and economic exploitation, it also serves to channel any criticism of this system into a safe and commonplace misogyny. In her death throes, "foaming, raving, roaring," swallowed by her own "accumulations"—the "huge quaggy carcass" of her flesh—Sinclair dies the self-consuming death that Richardson must spare the father: literally devoured by her own fat (1379, 1388). For the novel by no means condemns patriarchy but on the contrary deplores its inertia and its abdication to impostors who control the traffic in women and letters.

It is with the rape that Clarissa's abstinence turns into self-starvation. Her anorexia replaces her virginity, in the sense that her mouth rejects what her vagina proved unable to withstand. She starves in order to refuse all traffic with a world that threatens to invade her every orifice. When she is imprisoned at the Rowlands', Sinclair's whores rebuke her for her fast, taunting her with her own piety: "Your religion . . . should teach you that starving yourself is self-murder" (1054). Just as the Catholic prisoners at Long Kesh had to persuade their people and their priests that they were protesting by hunger, not by suicide, so Clarissa must exonerate her self-starvation.[38] Like the holy anorectics, Saint Catherine or Saint Theresa, she professes that she *would* eat but *can*not: "Nothing that you call nourishing will stay on my stomach" (1129). Incidentally, there is something comically modern in the way Clarissa's keepers glorify her shrinking figure, much as the daily press applauds Jane Fonda's training camps, or Princess Diana's compulsive dieting. Betty, Clarissa's nasty chambermaid, marvels that her mistress eats nothing, yet "never looked more charmingly" (263); while Belford is overawed by "what a lovely skeleton" she is (1231).

When her death is approaching, Clarissa says to Belford, "You must see that I have been consuming from day to day" (1276). In the first instance, she means that her body is wasting on her bones: and she is being medically precise, because the starving body eventually consumes itself in the absence of any other nourishment. As Betty reproaches her, "You lived of late upon air, and had no stomach to any-

thing," the reason being that "*your stomachfulness [has] swallowed up your stomach; and . . . obstinacy [is] meat, drink and cloth to you*" (264–265). (It is interesting that Richard Morton, who is generally thought to have discovered anorexia, actually classified it as a species of "consumption," and it was not until the nineteenth century that William Gull isolated it as a distinct disease.[39]) But it is unclear from Clarissa's syntax whether she is dying of the illness or the ethic of consumption, and whether she is suffering or perpetrating her decline. The ambiguity is telling, since her illness both resists her family and acquiesces in its woman-eating values. By refusing any input from the outside world, she parodies the boasted self-reliance of her class, exposing the absurdity and deadliness of the belief that subjects are autonomous and self-contained. Yet metaphorically, her pursuit of death vindicates her family's creed: for death, as Anna Howe puts it, "is as greedy an accumulator as themselves" (68).

The theme of self-consumption reemerges in the figure of the serpent biting its own tail, which adorns Clarissa's coffin at the end (1305):

> The principle device, neatly etched on a plate of white metal, is a crowned serpent, with its tail in its mouth, forming a ring, the emblem of eternity, and in the circle made by it is this inscription:
> CLARISSA HARLOWE.

An emblem of eternity, this snake could also stand for circulation, self-starvation, or imprisonment, all of which contribute to Clarissa's tragedy. Sacrificed to her society's ophidian orbit of consumption, she dies in order to ensure that women, money, and letters may circulate eternally. Indeed, the more her body wastes away, the more her epistles proliferate, for after the rape it takes her more than fifty letters to disenflesh herself sufficiently to die. In effect she writes herself into her coffin, or more precisely her *sarcophagus,* so named by the Egyptians because it was supposed to eat the corpse within. Indeed the novel

THE HUNGER ARTISTS

hints that writing is itself a process of sarcophagy, because Clarissa's epistles consume the very body that indites them.

Clarissa's letters instigate her ruin, since it is her "forbidden corre-spondence" that ensnares her in her rapist's net. But these letters also serve to clear her honor after she is dead, when the whole novel comes to represent a dossier for her defense and absolution. "What an army of texts has she drawn up in array against me," Lovelace exclaims (1473).[40] In a similar way, the inmates of Long Kesh embarked on a forbidden correspondence that later served as a memorial to their star-vation. They introduced a secret postal system that enabled them to transfer messages among themselves and with the outside leadership. These messages were known as "comms," short for "communica-tions"; they were written on cigarette papers, squeezed into tiny pel-lets, sealed in cellophane, and smuggled out in all the body's orifices.[41] Through these letters the prisoners gradually composed the epistolary history of their hunger strike, which David Beresford has recon-structed from their comms in *Ten Men Dead* (1987). Indeed, the less they ate, the more they seemed to write. Like Clarissa, their starvation generated a peculiarly prolix and rapacious literature, where words rushed in to fill the emptiness that food might occupy. That this lit-erature assumed an epistolary form in both *Clarissa* and the Long Kesh hunger strike is not surprising, insofar as food is the first letter one receives, the first comm to be inserted in one's body by the other. "In the beginning," Derrida quips, "was the post."[42] By this logic, self-starvation represents an anti-epistle, an abjuration of the post, a seizure of the interpsychic GPO. The letters teeming from these starving bod-ies overcompensate for their denial of the postal subjugation of the flesh.

In Long Kesh, letters actually take the place of food, because they occupy the thresholds of digestion—mouth, foreskin, anus—where love has pitched its mansion, too, as Yeats might say. The circulation of the post supplants the circulation of the body, substituting letters for the currencies of sex and food.[43] In this way, the comms expose

the deep complicities of sex and textuality that lurk beneath the surface of *Clarissa*. For the letter in *Clarissa* comes to stand for "female sexuality itself, that folded, secret place which is always open to violent intrusion," as Terry Eagleton has pointed out.[44] Clarissa and her postmaid, Hannah, are virtually strip-searched for the letters hidden in the innermost recesses of their clothes (120). The heroine herself invites her prying sister Arabella to put her fingers in her stays, "that she might be sure I had no papers there" (366). Similarly, Mrs. Harlowe, like the phallic mother, lifts her apron to reveal her "parchments," and Clarissa starts as if she had "produced a serpent" (339). Lovelace, too, attempts to seize Clarissa's letters long before he violates her flesh, lusting for the "pockets" where her secrets are concealed. "As to her pockets, I think my mind hankers after them," he sniggers. "But they cannot hold all the letters that I should wish to see. And yet a woman's pockets are but half as deep as she is high" (569). It is hard to tell if he is lusting for her words or for her flesh, because the theft of one entails the violation of the other. When he actually describes a letter that he snatches from her bosom as "the ravished paper," it is as if he had committed an epistolary rape (572).

Women, to Lovelace's delight, have many pockets in their bodies, and perhaps it is in envy of these built-in hiding places that men have such a superfluity of pockets in their clothes. In the Kesh, the male body was more prized for its interiorities than for its much-vaunted protruberances. Depth rather than length became the measure of genital superiority; for the prisoners would tuck their comms behind their teeth, jam them up their nostrils, or stuff them up their rectal passages. One prisoner was reported to have set the record by carrying forty cigarette papers in his foreskin. Another staggered out of Mass one day with "Mrs. Dale" (a miniature radio), a wad of comms, tobacco, a camera, and "Rennie Barker" (a Parker pen refill) crammed into his anus, thus earning the honorific of "the Suitcase." A prisoner whose code name was the Elephant "had his medication confiscated by a screw," according to a comm of Bik McFarlane's. "Medication" was a code name for a radio, which was also known as "Mrs. Dale" in honor of a popular BBC soap opera. These radios were tiny crystal sets

built into plastic medicinal tubes, which were smuggled into the H-Blocks in the traditional way—up the anus. "We wrap it up like a fish supper," quips Bobby Sands (and it is telling in view of the entanglements of food and words that fish and chips are traditionally wrapped in newsprint). The radio was reassembled in the cells, and the prisoners found that they could tune in several stations by manipulating the aerials in their mouths. So the mouth, already a postbox, becomes a radio receiver too, and the organs of the body are transformed into the organs of the news.[45]

The main weapon that the screws employed to intercept the comms was the humiliating mirror search. They would force the prisoners to squat over a mirror, often by sitting on their backs and subjecting them to blows and kicks at the same time. A metal detector was used to inspect the anus, and it also came in handy for beating the testicles.[46] It is appropriate that the mirror should become the badge of power and its cruelest implement: for it is by seizing the means of representation that the ruling powers have enforced their domination over Northern Ireland. While the mirror search deprives the men of their own speech, the comms they have secreted in their bodies, the larger mirrors of the censored press attempt to rob the Irish nation of its speech, to screw the comms out of the body politic.[47]

The comms themselves were often written to bear witness to the outrage of their own extraction, since the horrors of the mirror search were hard to prove unless the bodies of the prisoners were marked by visible mementoes of their violation. "This morning," one man writes, "more than thirty men were beaten during a wing shift—all were beaten while being forced over a mirror. S. Finucane has bruises on his legs. He is the only man who is marked."[48] Pain without marks is like speech without writing, doomed to pass into oblivion. This is why Anna Howe advises Clarissa to write the history of her misfortunes: "Write you should, I think, if you cannot speak . . . for words leave no traces; they pass as breath; and mingle with air, and may be explained with latitude. But the pen is a witness on record" (588). By writing, the prisoners attempt to overcome what Elaine Scarry describes in her semiotics of pain as its "resistance to objectification."[49]

Their words, therefore, replace their wounds, and their letters reinscribe the marks that violence has written on their flesh, that vanishing calligraphy of cruelty.

One might expect the authors of the comms to restrict themselves to vital information, considering the paucity of paper as well as the dangers and discomforts of conveying it. But the prisoners were more inclined to squander than to save their words. In the case of Bobby Sands, the first and most famous of the hunger strikers, his appetite for words seemed to increase in proportion to his abstinence from food: "He read voraciously," writes Beresford.[50] He also wrote incessantly and urged his fellow prisoners to follow suit. One inmate recalls, "He'd be doing books, writing poems, reading his poems out the door and encouraging other people to write. He was convinced that everybody had a book in him."[51] Similarly, the purpose of composing comms was not so much to deliver information as to salute the other members of the group and thereby to conscript them into the epistolary ganglion. In one of his comms, Sands complains, "There are I believe several tactics being deployed at present, foremost is I believe a deliberate policy of false disinterest that is 'we couldn't care less' type of thing to make me feel small or insignificant and to try to create the impression . . . that the hunger strike is merely confined to my cell."[52] The purpose of the comms is to subvert this strategy of isolation, both figuratively, by apostrophizing absent comrades; and performatively, by seeping through the walls that separate their bodies. The comms enable their conveyers to defy the loneliness of bodily experience, because their words themselves become a form of pain, their letters a form of penetration. Since it is impossible to feel the pangs, they eat the words of one another's hunger, or enwomb them in the shyest hollows of their flesh.

In one of his last letters, Sands admits that he is "disappointed that I never got a letter from the Dark even if it was just to say goodbye."[53] "The Dark" was the code name of Brendan Hughes, the officer in command of the H-Blocks, who shared a cell with Bobby Sands until the latter was removed to starve in solitude. In the context of Sands's approaching death, it is hard to disregard the resonances of the notion

THE HUNGER ARTISTS

of "a letter from the Dark." For the absence of the author means that every letter ultimately comes out of the dark to which its readers are destined to return, being themselves the s.a.e.'s of darkness. That the letter Sands desires from the Dark need only say goodbye shows that the purpose of the prison correspondence is ultimately to be hailed and thus to be enlisted into the fraternity.[54] In Sands's case, moreover, it is all the more important that his name should be inscribed into the group when his body is about to vanish from it. The comms he writes, as well as those that he receives and those that others write about him, serve to reunite the sacrificial victim to the cause and the community for which he suffers. A message from Bik McFarlane circulated after Sands's death exemplifies this sacrificial logic:

> Comrades, the death of our comrade Bob has left us all in great sorrow and though we had prepared for such a tragic event it nevertheless stunned each of us. I feel a great sense of personal loss also—in fact we all do—blanket men are more than comrades—they are brothers . . . May God take care of each of you and bless you.—Bik[55]

By substituting "brothers" for "comrades," McFarlane moves from the political into the moral or religious register; in the same way he changes "I" to "we," translating private grief into fraternal solidarity.

Each man chosen to join the hunger strike was instructed to write down his personal "details" for the perusal of the leadership. The result was that he would compose his own life story in the form of comms, which were henceforth hoarded for posterity. There is a sense in which the hunger striker is already dead as soon as he embarks upon this discipline of memory, for in this moment he surrenders food for words and life for legend. "Comrade, here goes with all my details," Bobby Sands begins his story, well aware that this comm, like every letter that he wrests out of his hunger, is more than likely to become his epitaph.[56] What is more, his autobiographical endeavors reenact the rigors of the hunger strike itself, insofar as both consist of the evacuation of the self. He writes his life in order to create his own memorial

but also to disgorge his mind of history, just as he devoids his body of the fat that represents its frozen past. As we have seen, Simone Weil argues that to starve is to renounce the past, "the first of all renunciations," because it is to rid the body of its larded history. In the Kesh, writing and starving both contribute to this disremembering, emptying the mind and body of the burden of the past. In this sense, the autobiographer consumes himself alive, because his flesh is deconstructed by the very words that constitute his afterlife.

Clarissa fasts against her rape, against the whole erotic code of which it represents the barbarous epiphany. But Bobby Sands and his successors starved to save the codes that distinguished them from ODC's, or "Ordinary Decent Criminals," to borrow Merlyn Rees's well-worn witticism. Their hunger, like Clarissa's, was a struggle for the sign: for the same violence may be described as a revolution or a crime, and the same act a marriage or a rape, depending on the power and the jurisdiction of the speaker.[57] To cite Pompey's profound tautology from *Measure for Measure,* any trade is legal "if the law would allow it." In Northern Ireland, the British government has played the "name-father," like Lovelace, suppressing opposition by altering its terms of reference. The criminalization policy was a flagrant case of this manipulation; and Long Kesh was also rechristened "The Maze," a fitting epithet for the policy of mystification that devised it.[58] Yet the prisoners were equally embroiled in this onomastic warfare, in which their bodies were the battleground and words the weaponry, for they claimed to be prepared to die for the symbolic meaning even of their clothes. It is telling that they also taught each other Irish as they starved, because they were reclaiming word and flesh at once, and rejecting any input from the colonizer.

The word "definition" literally means "the setting of bounds."[59] By resisting the bounds imposed upon their bodies the Irish prisoners were also struggling against the definitions imposed upon their acts. Bachelard points out that "language bears within itself the dialectics of open and closed. Through *meaning* it encloses, while through poetic

THE HUNGER ARTISTS

expression, it opens up."[60] Mrs. Thatcher's notorious tautology "A crime is a crime is a crime" aptly demonstrates how meanings can enclose and definitions circumscribe. The next chapter of this book turns to the problem of *imprisonment,* exploring how the physical enclosure of the body corresponds to the semantic enclosure of the word.

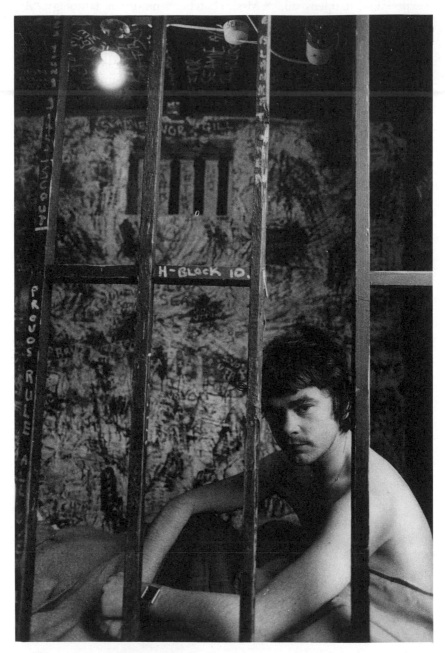

Mock H-Block cell in New Lodge area of Belfast

Encryptment

I have known a bird actually starve itself, and die with grief, at its being caught and caged—But never did I meet with a lady who was so silly.

—Lovelace to Belford, Clarissa

The reason that the hunger strikers of Long Kesh were driven into their illicit correspondence was that imprisonment prevented them from speaking to each other face to face. The same is true of Clarissa, who resorts to letters because she is imprisoned in her room and cannot importune her torturers in person. But is there something in the very nature of incarceration that drives these prisoners to starve as well as to commit themselves to ink? Even Kafka's hunger artist locks himself into a cage in order to perform his macerations; and prisoners in jail have traditionally used the hunger strike in order to protest against captivity and to give their words the weight that they have starved out of their flesh.

In *Wuthering Heights,* the themes of hunger and imprisonment are so closely interwoven that they virtually become synonymous with one another. Whenever Heathcliff is incarcerated, Catherine starves; the two motifs converge in Catherine's eerie cry, "Ellen, shut the window. I'm starving."[1] They also come together in an allegory Bobby Sands composed about a man who traps a lark into a cage. The lark goes on a singing strike, "and when the man demanded that the lark sing, the lark refused." The man became violent. "He starved [the lark] and left it to rot in a dirty cage but the lark still refused to yield. The man

murdered it."[2] This story reveals how hunger strikes invert the roles of self and other, challenging conventional ideas of agency. The inmates of the prison chose to fast, and also chose to foul their cells, but the mistreatment of the lark implies that they have been forsaken to their filth and forced to starve. So who is starving whom, and who is forcing whom to live in excrement? This question is built into the very structure of the verb "to starve," which can either mean to cause starvation or to suffer it. In any case, the parable implies that to be caged is to be robbed of food, bereft of voice.

The previous chapter examined the complicities of writing and starvation; this chapter examines how imprisonment contributes to these arts of disembodiment. Writing and fasting both attempt to rise above the flesh in order to escape its mortal bounds. Simone Weil argues that to hunger is to overcome the pull of "gravity" and to liberate the spirit from the prison of its flesh. This is the same argument that Seanchan makes for fasting in *The King's Threshold:*

> For when the heavy body has grown weak
> There's nothing that can tether the wild mind
> That being moonstruck and fantastical
> Goes where it fancies.

Writing resembles fasting in that both enable the "wild mind" to overleap the shackles of the flesh. "Nothing of body, when friend writes to friend," Lovelace says in praise of correspondence; and his terms imply that writing is itself a form a starving inasmuch as both activities reduce the flesh to nothingness.[3] What is more, the written word deserts the body of its author and "goes where it fancies," independent of his will. Thus the Irish Hunger Strikers used their letters as a way of walking through the walls imprisoning their bodies, relinquishing their all too solid flesh for the subtler ectoplasm of the signifier. Because the written word outlives the body, being wilder and ghostlier than flesh, it anticipates our final discarnation. Through writing we survive the grave but also die before our death, disenfleshed before our hearts have ceased to beat.

If writing and starvation circumvent the bounds imposed upon

the body from without, it is only by inflicting even deadlier constrictions of their own. Paradoxically, writing both releases and incarcerates, and starvation both immures and disenthralls. Hunger strikers, for example, resist the *external* limits of the institution, but only by creating an *internal* fortress of their flesh. By spurning food, they refuse to be influenced by the authorities or to swallow the values that their captors are ramming down their throats. Yet their sufferings reveal that this denial of the other necessarily entails the isolation and annihilation of the self. To fast is to create a dungeon of the body by rejecting any influx from the outer world; and writing also insulates the body, in the sense that it is possible to write even if one's ears are stopped and lips are sealed. It is telling that the letters of Long Kesh were actually used to plug the orifices of their own epistolers, because it demonstrates how writing, like starvation, fortresses the self against the world, perfecting its calamitous autonomy.

Kafka felt it was impossible to write unless he were immured against the influence of other beings. As he protested in a famous letter to Felice, his fiancée, who threatened to encroach upon his solitude: "That is why one can never be alone enough when one writes, why there can never be enough silence around one when one writes, why even night is not night enough."[4] For Kafka, writing is itself a process of encryptment, and his texts the burrows or the Chinese walls that defend their author from the shattering effects of immediacy. The imagery of enclosure that pervades his texts is implicated in the equally obsessive theme of hunger; the starving body, enclosed upon itself, represents a microcosm of the architectural and bureaucratic barricades that dominate his fictive universe. Most of the fasts in Kafka's tales actually take place in prisons: in the burrow, for example, or the hunger artist's cage. Gregor Samsa, too, is incarcerated in his room after he undergoes his metamorphosis, and in this crypt he loses the ability to eat, starved and silenced by his own "toothless jaws." Similarly, the investigating hound is forced to isolate himself from other dogs in order to achieve the super-canine feat of self-starvation, because he finds the talk of food even more enticing than its presence. He shuffles off the double yoke of food and speech to venture to the limits of corporeality. The tenant of the "The Burrow" declares that

he would rather starve than let the "small fry" perforate his stronghold. In fear of their invasion, he hoards his food instead of eating it; and thus the passageways of his intestinal abode are blocked with stockpiles of uneaten flesh, a putrid monument to his askesis.

Deleuze and Guattari connect the carceral motif in Kafka's fiction to the "cramped space" of German-speaking Jews in Prague; it is possible that the motif of self-starvation in his writing stems from the same source. Kafka's hunger artists, who reject all food, resemble their creator, who rejects all words but those of his deracinated enclave. The isolation of the faster in his stories also seems to stand for the seclusion of the writer, incarcerated in the chambers of the night. The burrow, for example, which imprisons its own artificer, provides a mirror image of the catacombs of texts in which the author undergoes a living burial. While Kafka's stories tend to take the point of view of the builders or inhabitants of hideaways who usually fail to keep intruders *out,* his novels take the point of view of outsiders who think that they are trying to get *in,* only to discover that they have been interpolated in the structure all along. The law of writing, similarly, is to be inside out and outside in, the prisoner of apertures and pervious enclosures; as Kafka writes, "How can a wall protect if it is not a continuous structure?" (235). The same question could be asked of the fasting body; "this shattered prison," as Catherine describes her starving flesh in *Wuthering Heights* (chap. 15). The body also fails to insulate the self against the world because it is "not a continuous structure"; and the gaps in its integument imply that it is constantly invaded by the flesh and words and influence of others.

Nonetheless, the very notion of the self, the unified integral individual, is founded on the model of incarceration. It was in the seventeenth and eighteenth centuries, the age that Foucault calls the Great Confinement, that workhouses, asylums, and penitentiaries were built in order to conceal the criminal, the destitute, and the insane from public view; and it was also in this era that the modern conception of the individual was born. To be a person is to be a prison, this historical coincidence suggests; and in the keep of subjectivity, the solaces of privacy are always counterbalanced by the terrors of eternal solitude. T. S. Eliot writes:

THE HUNGER ARTISTS

> I have heard the key
> Turn in the door once and turn once only
> We think of the key, each in his prison
> Thinking of the key, each confirms a prison
> *(The Waste Land,* lines 412–415)

Psychoanalysts like Klein and Abraham have argued that the notion of confinement derives from infantile fantasies of cannibalism. In order to engorge the other a dungeon must be hollowed out in which the not-self is immured into the self. As Derrida puts it, "a door is silently sealed off like a condemned passageway inside the Self," in which the undead objects of incorporation are enclosed.[5] This connection between eating and encryptment is confirmed by slang, in which the mouth is rudely called a "trap." If eating, therefore, is imprisonment, self-starvation seems to represent the extirpation of the other from the self. Yet starving also keeps the other *in* and fortifies the stronghold of the ego, lest the ghosts within the self should break out of their tomb.

To pursue these issues further it is necessary to explore the metaphoric structure of specific texts. The next part of this chapter examines the dynamics of imprisonment in *Clarissa* and the Irish Hunger Strike. Finally I turn to works by Victor Serge, Wole Soyinka, J. M. Coetzee, and Primo Levi to show how writing and starvation are implicated in imprisonment.

Clarissa is an epic of incarceration. To read the novel is to watch its heroine travel "from one confinement to another," as she puts it, from Harlowe House to Sinclair's to prison to the grave (393). Throughout the text she finds herself enframed in keyholes, doorways, prisons, mirrors, letters, clothes, and even in her body, which she actually calls a "frame": "this dreadful letter has unhinged my whole frame" (513). (Of course, this metaphor is rooted in Christian thought, in which the body is traditionally pictured as an edifice, at best a temple and at worst a prison.) If her frame has been "unhinged" by letters, this implies that her flesh has been dismantled by her words; and indeed, her

letters seem to deconstruct her mortal frame until she lies encrypted in her texts, devoured by her own ferocious alphabet.

Clarissa sees herself as the protecter of limits: that is, of "the fences and boundaries of moral honesty" (613). What is curious, however, is that every boundary in the novel seems to be constructed only to be violated, as if the very act of circumscription elicited its own transgression. Bik McFarlane discusses this strange logic in a comm to Gerry Adams: "I still don't think [the British] have learned that oppression breeds resistance and further oppression—further resistance!! . . . Tom McKearney quoted me a bit of Rudyard Kipling (I think that's the guy who makes exceedingly good cakes!). According to old Rudy the British are immune to logic."[6] McFarlane's argument that oppression breeds resistance corresponds to the psychoanalytic principle that repression inaugurates desire. The same principle controls Clarissa's fate, because it is precisely the restrictions on her letters and her body that compel them both to circulate so furiously. It is her imprisonment that forces her to turn to letters, and it is the law of silence that her father imposes on her correspondence that unleashes its insatiable verbosity. Indeed, Clarissa's letters leak out of the family house like bodily secretions from the skin, more incontinent for every effort to suppress them. She describes these texts as her "written deposits" (66): the term "deposit" has both fecal and financial undertones, implicating excrement in increment, and surplus waste in surplus value. But it is precisely the paternal ban that triggers this epistolary pullulation, and every effort to impede the post only seems to make it more exuberant.

Similarly, Lovelace never tires of repeating that his molestation of the heroine would be no fun if it were not for the tenacity of her defenses: "Her virtue, her resistance," he boasts, "are my *stimulatives*" (716). Thus it is the very rigor of her modesty that arouses his "encroaching" lust. When he fails to bend her with his words, he finally resorts to rape to overcome the flimsier defenses of her flesh. Yet as many commentators have pointed out, the rape is cloaked in ambiguity. Indeed, it never quite occurs. In a novel scarcely given to laconism, Lovelace's report of the event is curiously telegraphic: "I can go no farther . . . Clarissa lives" (883). This strange omission in the

center of the narrative compares to Freud's conception of the "navel of the dream," in which so many of the dreamer's thoughts converge that meaning, in its very density, dissolves, leaving an uninterpretable fissure in the dream-text.[7] In *Clarissa,* the rape is also "overdetermined," like the navel of the dream, in that it epitomizes all the text's disputed or invaded borderlines.

All enclosures are a stimulant to Lovelace's encroachments; he violates the boundaries of morals, meanings, letters, bodies, and buildings with the same gusto. The last of these enclosures is Clarissa's coffin, which also functions as an envelope, since her carcass is entombed in its inscriptions and forwarded to her paternal home as a posthumous letter. Yet Lovelace even tries to intercept this ultimate epistle. Since the rape has failed to satisfy his passion for invasion, he has nothing left to desecrate except her tomb. "I think it absolutely right that my ever-dear and beloved lady should be opened and embalmed," he declares (1383). His plans for her dismemberment reveal the murderous fantasies that drove him to the rape, for he proposes that her heart should be bequeathed to him, her bowels to her rancorous relations (1384).[8] Since he perceives her body as an envelope he cannot rest until he rips it open; the rape is a poor substitute for disembowelment. Nothing less than her disintegration will placate him; but Clarissa, too, will settle for no less, and her dispersal of her worldly goods is a financial version of his fanciful evisceration of her carcass. The effect of both is to ensure that she remain in circulation, martyr to the mail.

Clarissa's death does not defeat the post but, on the contrary, sustains it. The whole epistolary system of the text depends on her encryptment, whether in her chambers or the tomb. By imprisoning Clarissa, her father and her rapist engineer the absence necessary to the interchange of mail, which depends upon the separation of sender from recipient. Thus the very embargo that her father imposes on the post prepares the way for the entire love-lace of erotic and epistolary correspondence. Yet if imprisonment induces writing, the converse is also true, because the "scribblers" of *Clarissa* voluntarily incarcerate themselves whenever they experience the urge to write. "He instantly shut himself up to write," says Charlotte of her cousin Lovelace (1048); and Clarissa also writes her letters only when she can be sure that all

the locks and fastenings are tight (529; 325). Clarissa describes her writing as a "*compact* with myself" (483). This conception of the self is embodied in the epistles themselves: sealed, inviolate, and confidential like the private rooms in which they are indited. Ruth Perry has argued that architectural changes in the eighteenth century and the specialization of space within houses guaranteed a "hitherto unknown privacy—a condition which has its own place in the origins of fiction." For this reason epistolary novels constantly return to the scene of a character shut up alone in a room with some paper and a pen. In *Clarissa,* the private chamber comes to symbolize the private body and the carceral containment of the self.[9] When the heroine says, "I expect to be uninvaded in my retirements" (457), she could be referring either to her body, her letters, or her room, whose closets, drawers, keyholes, bolting doors, and curtained windows represent the vulnerable secrets of her flesh and mind. Similarly, the "private drawer of [her] escritoire" (99), in which Clarissa conceals her correspondence, serves as a metonymy for the intimacies of her consciousness and her virginity; while her virginity, in turn, becomes the fetish for the myths of moral, economic, or corporeal autonomy that legitimate the domination of her class.[10]

Clarissa's letters are also little prisons all too easily encroached upon. Often, these letters are themselves enclosed in Lovelace's letters to his friends, so that her writings are imprisoned in his envelopes much as her body is imprisoned in his walls, the former sealed with wax, the latter barred with iron. If the letter is a prison, the converse is also true, because the prison in *Clarissa* is depicted as a letter where the captive is enveloped in inscriptions. The cell in which Clarissa is imprisoned at the Rowlands' is "smoked with variety of figures, and initials of names" (1064), like a letter with a hundred authors, each annihilated in the act of signature. These figured and initialed walls foreshadow the devices on the coffin where Clarissa is "penned in" eternally; but they also represent the whole epistolary system that demands her burial alive. Indeed, the image of a living burial haunts her discourse and her dreams, for she perceives it as her last alternative to sexual enslavement. She would rather be entombed alive, she says, than marry Solmes, or suffer Lovelace's "ghost-like" intrusion in her

THE HUNGER ARTISTS

home (101, 142); and at one point she dreams that Lovelace dumps her in a "deep grave ready dug" and buries her among dissolving carcasses (342–343). In Richardson, writing *is* a kind of burial, since it is always testamentary, and this is why Clarissa slowly writes herself into her grave. The letter is necessarily "written afterwards," as Lovelace says, and even his "lively *present-tense* manner" cannot overcome the suicidal logic of his writing (882). He laughs in letters, yawns in letters, splutters and ejaculates in print, as if to burst into the present through convulsion. But in *Clarissa,* men come too early while their letters always come too late, and writing is posthumous from the very moment of inscription. "Clarissa lives," says Lovelace after he has raped her; but Clarissa knows that she is dead, for she is "nothing" but the will she writes to make up for the will he robbed her of. A codicil to her own testament, she dissolves into a wake of legacies.

What could Clarissa's prisons have in common with the H-Blocks of Long Kesh, and how could her luxurious captivity compare to penal servitude? Foucault would argue that the penitentiary is only the terminal form that power takes, for it inheres in all the bonds of knowledge, sexuality, or economics that intertwine the public and the private spheres.[11] It is in torture, though, that power finds its deadliest hyperboles, and many of the figures of its savage speech surface in *Clarissa* as well as in the Irish Hunger Strike. Elaine Scarry, in *The Body in Pain,* argues that the founding trope of torture is to reduce the world "to a single room or set of rooms."[12] Clarissa undergoes this ontological reduction just as literally. If, for Donne, love "makes one little room, an every where," Clarissa's sexual subjection turns the world into a little room whose walls are steadily contracting around her frame.[13] As we have seen, the rooms in which she is imprisoned shadow forth the contours of her own anatomy, mapping the portals of invasion as well as the avenues of pain: the drawers, cabinets, and closets represent her body's pervious interiorities. In Long Kesh, though, the distinction between room and person virtually disappeared, because the inmates imprisoned themselves in their own substance by caking their cell walls with excrement. Although their world had been reduced to four

cramped walls, within that tiny compass self was everywhere.[14] Through the dirty protest, they were striving to reclaim their cells, just as they reclaimed their bodies through the hunger strike, for they cocooned themselves into their excremental signatures.

Scarry points out that the words for torture are often borrowed from the lexicon of domesticity, which indicates an ominous affinity between the two domains. For example, the torture chamber has been called the "guest room" in Greece and a "safe house" in the Phillipines.[15] These epithets reveal that torture mimes the comforts of the home, much as Clarissa's prisons mock the luxury of privacy. Domestic objects are perverted into instruments of pain: tables and chairs are used as racks and bludgeons, contradicting their hospitable associations; electric lamps blaze day and night, destroying time and using light to dazzle rather than to see. By contrast, Walter Benjamin has argued that "living means leaving traces," and that the crowded Victorian interior was especially equipped to preserve the traces of the human form in its velvet and upholstered surfaces.[16] In the torture rooms of Northern Ireland, all such traces were erased; even language was replaced by the clamor of machines, broken only by the sound of mortal cries. This is how one victim, Patrick Shivers, described the notorious "disorientation techniques" used by the RUC Special Branch, which were exposed by an Amnesty investigation in 1971:

> I was taken into a room. In the room there was a consistent noise like the escaping of compressed air. It was loud and deafening. The noise was continuous. I then heard a voice moaning. It sounded like a person who wanted to die. My hands were put high above my head against the wall. My legs were spread apart. My head was pulled back by someone catching hold of the hood and at the same time my backside was pushed in so as to cause the maximum strain on my body. I was kept in this position for four, or perhaps six hours until I collapsed and fell to the ground. After I fell I was lifted up again and put against the wall in the same position and the same routine was followed until I again collapsed. Again I was put up and this continued indefi-

THE HUNGER ARTISTS

nitely. This treatment lasted for two or three days and dur-
ing this time I got no sleep and no food. I lost consciousness
several times.[17]

Here it is the body that torments the body, without external weaponry.
The room becomes a pain-scape where every corner represents a dif-
ferent agony, and even the angle of the wall and floor provides the
scaffold for a bloodless crucifixion. Furthermore, the boundary be-
tween the inside and the outside, fundamental to the concept of the
self, dissolves, because it is impossible to tell from this account
whether the wailing is coming from the walls or from the prisoner.
Starved of vision, stuffed with sound, the self disintegrates because it
cannot regulate its intake of reality.

Sylvia Pankhurst suffered the same breakdown of identity, al-
though it was her gullet that was gorged with food, rather than her
ears with noise. Bachelard argues that the being of man should be
"considered as the being of a *surface,* of the surface that separates the
region of the same from the region of the other."[18] In Pankhurst's case,
or Shivers's, this surface is ruptured, for the regions of the other and
the same can no longer be held apart. The body has become an open
wound: all mouth, all ears, all orifice. Patrick Shivers, incidentally,
never was a member of the IRA, and the £15,000 he was awarded by
the international court for damages did not assuage his lasting psychic
injuries.[19]

In torture, Scarry writes, "the pain is traditionally accompanied
by the Question." It is therefore telling that the pages of *Clarissa* are
also dominated by the scene of inquisition. But Lovelace's eternal
question is a pretext rather than a motive for the torments he inflicts
upon the heroine. Her consent could only disappoint him because it
would dissolve the theatre of interrogation where his will to power
finds hallucinatory satiety. According to Scarry, torture is the only lan-
guage that combines with such intensity "the modes of the interro-
gatory, the declarative, the imperative, as well as the emphatic form
of each of these three, the exclamatory." Lovelace, though, avails him-
self of all these modes, thus revealing a disturbing kinship between the
language of torture and the language of love. In the Kesh, however,

torture dispenses with the question, which is always bluff in any case, since no reply could ever warrant the agony of its extraction. In the mirror search, the physical and verbal sides of torture coalesce; for rather than demanding a confession from the prisoners, the warders literally wrench their answers from the flesh.

The torture room provides the mise-en-scène where power materializes in the spectacle of pain. The fact that it was called the "cinema room" in South Vietnam signals the importance of the ocular and voyeuristic aspects of the ritual.[20] Similarly, in the mirror searches of Long Kesh, the eye itself becomes the instrument of violation, symbolically impaling the bodies that it scrutinizes. Bobby Sands reports a search in which the prisoners were forced over a table and "the cheeks of their behinds torn apart by the screws' hands." "Comrade," he concludes, "this is sexual assault." It is also torture—as the women prisoners of Armagh recently protested when they were subjected to the same barbarities.[21] What is more, the spectacle of nakedness titillates the clothed with the delusion of their own superiority. As Naomi Wolf writes in *The Beauty Myth:* "Cross-culturally, unequal nakedness expresses power relations: male prisoners are stripped in front of clothed prison guards; young Black male slaves were naked while serving the clothed white masters at table."[22] The same could be said of pornographic photographs, which appeal not only to the viewer's prurience but also to infantile notions of omnipotence, since the tantalizing object looks as if it were imprisoned in the gaze, petrified by the Medusan eye. Curiously, the verb "to stare" is related to the verb "to starve," which used to mean to freeze or turn to stone. Milton's devils, for example, "starve in Ice."[23] One could argue that the inmates of Long Kesh starve in *eyes:* for staring and starving both have the effect of reifying bodies into spectacles. These spectacles, moreover, mystify the true relationships of power, because it is the individuals who are humiliated rather than the social forces that they represent. But it is precisely this confusion of the symbol with the symbolized which underlies this rhetoric of laceration.

Clarissa's prisons, too, provide the stage where Lovelace makes a scene of her subjection. Because he imagines he can freeze her with his eyes, her visibility becomes the trophy of his mastery. Indeed, he

THE HUNGER ARTISTS

relishes the *spectacle* of power even more than the physical *abuse* of it. Hence his consternation when Clarissa "steals" herself away, because it is as if the subject of a portrait had risen up and walked out of its frame. Even when she bolts her door he gazes at her through the key-hole, as through an orifice that can no longer be closed. This keyhole literally frames her image, capturing her charming attitudes of sexual and mortal agony in a series of tableaux that circulate among the masculine confederacy. For Lovelace recounts these scenes for the amusement of his rakish friends, who are the ultimate recipients of both his letters and his lust. In the first part of the novel, he narrates Clarissa's defloration, while Belford, in the second, tells the story of her death; and yet the scenes that they depict are often mirror-images of one another. Shortly before the rape, Lovelace bursts into Clarissa's room after setting fire to the house in the hope of terrifying her into his arms. He describes how "her night head-dress having fallen off in her struggling, her charming tresses fell down in naturally shining ringlets, as if officious to conceal the dazzling beauties of her neck and shoulders" (725). Later in the novel, when Belford finds Clarissa imprisoned at the Rowlands', he recreates this primal scene, invoking the same imagery of soft pornography: "her headdress was a little discomposed; her charming hair, in natural ringlets, as you have heretofore described it, but a little tangled, as if not lately kembed, irregularly shading one side of the loveliest neck in the world; as her disordered, rumpled handkerchief did the other" (1065). Although Belford is ostensibly re-buking Lovelace for reducing Clarissa to this plight, the verbal repetitions hint that he is implicated in her degradation. He also "frames" the heroine and swaps his verbal pin-ups of her death in exchange for those of her torturous seduction.

Clarissa leaves the strictest instructions in her will forbidding Lovelace to see her corpse, because she feels she has been captured by his eyes as much as by his locks and keys. In fact, she believes that he has seen her dead already, when he raped her: "*Once dead,* the injured saint in her will says, *he has seen her,*" as Belford puts it (1447). This strained locution hints that she was violated by the gaze itself, and perhaps that she was murdered by it too. By dying she is trying to escape a bodily disgrace that is nothing other than the stain of visibility

itself. Clarissa starves *herself* in preference to being starved, or turned to stone, by the pornographic stare of her seducer. In this novel, to see is to ravish, to petrify, and even to engorge the seen into the eye, an organ known for its rapacity: witness Cassius's "lean and hungry look," or children's eyes, which are notoriously bigger than their stomachs. "In this matter of the visible," Lacan writes, "everything is a trap."[24] Perhaps the reason why the eye is traditionally evil is that it "gobbles" up whatever it beholds.[25] As the eye grows fat the world grows thin, starved by its insatiable stare.

In the Irish Hunger Strike the prisoners were starving for the eyes of Mrs. Thatcher, which she kept intransigently shut. She assumed the same position as the absent father in *Clarissa,* because she also occupied the place of blindness in the system of exchange. This blindness astounded Cardinal O'Fiaich when he appealed to her in 1981 for a solution to the crisis in Long Kesh, for she pretended that she could not understand the issues. "Will someone please tell me why they are on hunger-strike? I have asked so many people," she complained. "Is it to prove their virility?"[26] Of course, this question was a crafty way of hinting that their manhood needed to be proved. Silly as it is, this insult shows how the delusions of imperialism are reinforced by those of sexuality. Thatcher, in this instance, conflates the colonial with the emasculate, figuring political impotence as sexual unmanliness. By misreading the Irish body she symbolically castrates it. However, the prisoners themselves were equally misled by sexual stereotypes, because they underrated the intransigence of their opponent, crediting Mrs. Thatcher with a maternalism that anyone outside the Kesh would have found extraordinary. Belatedly acknowledging their error, they dubbed her "Tinknickers": an honorific that resembles the politer epithet "The Iron Lady," yet also brings its latent obscenity to light.[27] But it is revealing that the atrocities of male politicians are usually imputed to their brains, whereas Mrs. Thatcher's were imputed to her genitals. The phallicism of these nicknames hints that Thatcher is defeminized by her rigidity, but also that she owes her power precisely to outstiffening her soft and unmetallic sisters.

In the postal system of Long Kesh, her tin knickers mean that she is proof against all comms as well as all compassion. They mean

THE HUNGER ARTISTS

that she can neither receive the messages that circulate among the bodies of the prisoners, nor the bodies themselves—human comms—that file out of Long Kesh in their coffins. But if nothing can get into her tin knickers, it is equally the case that nothing can get out, because the term implies retentiveness as well as chastity. Traditionally the bowels were the seat of the compassion that Thatcher so obdurately lacks, and the name Tinknickers may owe something to that lore. In Long Kesh, though, it was the bowels that provided the excremental ink with which the inmates autographed their cells, defying their containment with incontinence. It is as if the body had exploded like a bomb—a more familiar spectacle of Irish protest—and splattered its ruins in graffiti. Of course, writing and bombing have a good deal in common, in that both imply the absence of their authors and both depend upon deferred effects: the two converge in the concept of the letter bomb. Through the dirty protest, the prisoners were attempting to return to a writing earlier than speech and even earlier than body, if body is considered unified and self-contained. Thatcher's tin knickers, on the contrary, symbolize the law of continence, which defines the boundaries of the body and initiates the infant into culture. In fact, the continent body represents the prototype of prisons and of all the other limits and enclosures that define the social space. By refusing food and cleanliness and even clothes, the prisoners were attacking this demonic mother of confinement with the most effective and indeed the only weapons of the child. Knickerless themselves, they were rejecting the most primal signs of cultural inscription.

As we have seen, the notion of the self is founded on the regulation of the orifices. For it is at these thresholds that the other, in the form of food, is assumed into the body, and the body, in the form of waste, is expelled into the empery of otherness. This "continual flux between inside and outside," in Margaret Atwood's words, maintains the economy of subjectivity: "taking things in, giving them out, chewing, words, potato chips, burps, grease, hair, babies, milk, excrement, cookies, vomit, coffee, tomato-juice, blood, tea, sweat, liquor, tears, and garbage." In prisons, where the outside world shrinks into the

narrow compass of a cell, the inside world is correspondingly depleted. Thus the "intake of food and the output of words" are both deranged.[28] Wole Soyinka, who went on hunger strike when he was imprisoned in Nigeria, reveals that he rejected *food* in order to protest against the dearth of *words* that he suffered in his solitary confinement. "Why do I fast?" he writes. "I ask for books, writing material . . . I also ask for an end to my inhuman isolation."[29] His hunger symbolizes the starvation of his intellect, which has already exhausted its resources: "To feed my body but deny my mind is deliberate dehumanization." The mind cannot survive upon its stores of memory alone, any more than the body can subsist upon its fat: "My first twelve months had used up more than the normal creativity of a mind that received no replenishment from other sources." The digestive processes of intellect depend upon "exchange . . . within a community of other minds." By "regurgitating" the ideas that he has already consumed Soyinka walls himself into a "mental prison": "I cannot circle indefinitely in the regurgitations of my mind alone," he protests. On the other hand, the minds of the officials in the prison represent the very opposite of food, its excrement: "They are pus, bile, original putrescence of Death in living shapes," he writes. "I smell a foulness of the mind in the mere tone of their words." His hunger strike, therefore, asserts a wild freedom from the fetor of their speech: "I must reach that point where nor mind nor body of me can be touched, move beyond the capacity of small minds to soil my being or reach towards it. It has not been fasting alone. I have let my psyche roam free, seeking them, learning to destroy them when the time comes." Soyinka hints that his starvation will incapacitate his captors rather than himself, because his psyche is liberated from his flesh to roam destructively at large.[30]

At the same time that he decides to fast, Soyinka starts to send out letters from his cell, revealing the profound collusion between writing and starvation. In both activities, the captive strives to "captivate" the other, either with his words or with the mute apostrophe of his emaciated flesh. Soyinka uses writing as a method of deliverance, because his letters externalize his thoughts and thus release him from his intellectual autophagy. These letters also feed upon his wasting

flesh, overcompensating for the dearth of food with a veritable battery of words, like the letters of Clarissa and the Irish prisoners. It is curious, in all these cases, that the flow of words seems inexhaustible, whereas the individual emissions, comms or letters, tend to be extremely small. Similarly, Sylvia Pankhurst felt that the sphincteral confinement of the prison cell demanded she restrict her writings to "the most concentrated form of expression." After being force-fed, she would purge herself of words as well as food, until the events she chronicled "were too hateful to be dwelt upon." Fearing that her secret store of paper would "be filled up too quickly," just as her body had been filled too full and devastated by its savage nutriment, she learned to ration her outpourings into poetry. "After the torturers had left the cell," she writes:

> I would . . . lie still and, when I could, clean off all the filth left from the outrage—and put myself to write on my precious store of paper, cautiously lest I might be surprised. At first I kept a regular diary, but as the toll of days lengthened into weeks I lost heart in it; the events it chronicled were too hateful to be dwelt upon. I gave it up and used my paper for more inspiring things, with fear that it might be filled up too quickly. With this thought I wrote verse as the most concentrated form of expression.[31]

In Pankhurst's poems, as in the Irish Hunger Strikers' comms, the sparsity of words reflects the deprivations of the body, contracted by its hunger as much as by the prison bars. Yet this diminishment of words, like that of flesh, is experienced as distillation rather than reduction, because it fosters the enlargement of the spirit. Soyinka writes, "My body dwindles but . . . my mind expands."[32] Other hunger artists, too, emaciate their language in order to intensify their vision. Emily Dickinson, for instance, creates a "banquet of abstemiousness" in her verse, a kind of cornucopia of reticence. Similarly, Simone Weil strives to make her words as weightless as her flesh: the aphorism, like the lyric, enables language to escape the "gravity" of history, so that words float free of context and contingency, groundless and "inebriate

of air." Nonetheless, her verbal pellets, squeezed out of her starving flesh, also involve the anal sadism implicit in the comms or in the fusillade of letters that Soyinka unleashes on his jailers.

Another work in which the themes of hunger and imprisonment are intertwined is the *Life and Times of Michael K.* In this novel Coetzee updates Kafka's "Hunger Artist," setting his "allegory" of starvation in the not so distant future in South Africa and in the final bloodbath of apartheid. The eponymous hero bears the same initial (K) as Kafka's heroes in *The Trial* and *The Castle;* but he also bears a strong resemblance to Meursault in Camus's *The Outsider,* in that he refuses to obey the social code yet finds himself unable to account for the "originality" of his "resistance."[33] In the first part of the novel, Michael K escapes the refugee camp where he has been corraled by the authorities, but he retreats into the Kafkaesque enclosure of a burrow. Here he slowly starves to death: "In his burrow . . . his own need for food grew slighter and slighter" (139). Eventually he is recaptured, but starvation drives him to aphasia rather than loquacity, and it is left to the officials in the camp to interpret the enigma of his disembodiment. "Are you fasting? Is this a protest fast?" they question him (199). Michael K does not reply, for he is "not a hero and [does] not pretend to be, not even a hero of fasting" (223–224). Instead, he starves his body in order to be free of the "hunger for belief," the "craving for meaning": the mind's insatiable appetite for sense (226). His residence in the camp is "merely an allegory . . . of how scandalously, how outrageously a meaning can take up residence in a system without becoming a term in it" (228).

The police describe the refugee camp as a "nest of parasites hanging from the neat sunlit town, eating its substance, giving no nourishment back." To Michael K, however, "it was no longer clear which was host and which parasite, camp or town. If the worm devoured the sheep, why did the sheep swallow the worm?" (159) Michel Serres has argued that society consists of "innumerable vampires and bloodsuckers attached in packets to the rather rare bodies of the workers"; but Michael K's starvation frees him from the roles of either host or parasite, sheep or worm.[34] He not only escapes the systems of use-value and exchange-value whereby his "bizarre shape" (204) might have been converted into meaning, but also the parasitic system of "abuse-

value," which sabotages both of those economies. He is too redundant to the flow of food and words and money even to derange their circulation, and Coetzee's imagery suggests that he does not belong to the organic order. Rather than a parasite who feeds upon the state, Michael K is a gallstone who inhabits it, giving nothing and receiving nothing.

Coetzee envisages the prison as the stomach of the state in which its fractious victims are engorged; and Michael K, like Serge's Ryzhik, struggles to escape its cannibalism by refusing to consume its food or its illusions. For this reason both these characters are described as stones that pass "through the bowels of the state undigested" (221): "I am a stone carried along by a dirty flood," thinks Ryzhik;[35] while Michael K is "like a stone . . . A hard little stone . . . enveloped in itself and its interior life. He passes through these institutions and camps and hospitals and God knows what else like a stone. Through the intestines of the war" (185). If Walter Benjamin argues that "living means leaving traces," Michael K embodies the belief that "A man must live so that he leaves no trace of his living" (135). Like Oedipus at Colonus, who dies without leaving a corpse, Michael tries to die without bequeathing either a body or a story, "so obscure as to be a prodigy" (195). However, since he knows that even people who die of starvation leave bodies behind, he can only hope to disappear from history if he starves himself of words as well as food (129). To speak would be to give himself the "substance" that his hunger has erased, to undo all the labor of his discarnation. "Listen how easily I fill this room with words," the officials urge him. "Give yourself some substance, man, otherwise you are going to slide through life completely unnoticed" (192). "It is time to deliver . . . You've got a story to tell . . . Do you want the story to end with you?" they demand. "Where is your stake in the future?" (191). Michael K makes no reply. Like the fire, "consuming itself and being consumed" (123), he eats his words and starves his flesh, for both are swallowed up into the "hole" of his unspeakable and unrememberable being: "Always, when he tried to explain himself to himself, there remained a gap, a hole, a darkness before which his understanding balked, into which it was useless to pour words. The words were eaten up, the gap remained. His was

always a story with a hole in it" (150–151). It is not to give his life a meaning that he fasts, but to give this "hole," this emptiness, its savage effigy.

Soyinka also hints that his grievances against his captors are merely pretexts for a fast that has transported him beyond the whole economy of meaning. Ultimately he is not hungering for any nameable advantage but in order to give lack a "shape and form." Thus he fasts "towards nothing": "It had to be quantitative, not a brief feat of endurance whose sharp collapse would leave no choice but such indignities as forced feeding. If I could fast in such manner as to avoid the symptoms of collapse, holding up my body by gently hiving off the flesh, accustoming the body to less and less till finally—nothing."[36] "Nothing" is the term that Cordelia in *King Lear* offers to her father in the place of "love." Similarly, Soyinka starves in order to embody the nothing that engenders love insofar as it implies the interdependence of all beings. As Yeats writes:

> . . . I know
> That out of rock
> Out of a desolate source
> Love leaps upon his course.[37]

By starving, Soyinka becomes the bearer of the empty place, the desolate source, whose role is to reveal the networks of exchange in which all feeders are enmeshed. According to Lewis Hyde, "the gift moves toward the empty place": "As [the gift] turns in its circle it turns toward him who has been empty-handed the longest, and if someone appears elsewhere whose need is greater it leaves its old channel and moves toward him. Our generosity may leave us empty, but our emptiness then pulls gently at the whole until the thing in motion returns to replenish us. Social nature abhors a vacuum."[38]

The mission of the hunger artist is to incarnate the emptiness that instigates the circulation of the gift. This absence generates the flow of food and letters and all the other objects of exchange that move through subjects in pursuit of their mysterious trajectory. It is not compassion, then, that forces us to meet the faster's wishes, but the

THE HUNGER ARTISTS

systems of exchange that implicate us in his fate because they override the boundaries of the self. Compassion is the name we use to humanize the *post;* that is, the "thing in motion" that compels us towards the empty place.

Primo Levi, in his memoirs of Auschwitz, recalls two dreams that racked his nights and those of his fellow starving prisoners: the dreams of the food that could not be eaten and of the words that could not be heard. He remembers how his sister would appear in the dream "with some unidentifiable friend and many other people. They are all listening to me and it is this story I am telling": the hard mattress, the cold bones of the stranger in the bed, the sufferings of labor, the blows of the officials, the pangs of hunger.

> It is an intense pleasure, physical, inexpressible, to be at home, among friendly people and to have so many things to recount: but I cannot help noticing that my listeners do not follow me. In fact, they are completely indifferent: they speak confusedly of other things, as if I was not there. My sister looks at me, gets up and goes away without a word.
>
> A desolating grief is now born in me, like certain barely remembered pains of one's early infancy . . . My dream stands in front of me, still warm, and although awake I am still full of its anguish: and then I remember that it is not a haphazard dream, but that I have dreamed it not once but many times since I arrived here . . . that it is also . . . the dream of many others, perhaps of everyone. Why does it happen? Why is the pain of every day translated so constantly into our dreams, into the ever-repeated scene of the unlistened-to story? . . .
>
> I look around and I listen. One can hear the sleepers breathing and snoring: some groan and speak. Many lick their lips and move their jaws. They are dreaming of eating: this is also a collective dream. It is a pitiless dream which the creator of the Tantalus myth must have known. You

ENCRYPTMENT

not only see the food, you feel it in your hands . . . you are aware of its rich and striking smell; someone in the dream even holds it up to your lips, but every time a different circumstance intervenes to prevent the consummation of the act. Then the dream dissolves and breaks up into its elements, but it re-forms itself immediately after and begins again, similar, yet changed; and this without pause, for all of us, every night and for the whole of our sleep.[39]

These dreams mirror one another, coalescing and disbanding, with their never-ending repertoire of unsaid words and undevoured food. The mouths that lick their lips and move their jaws are also squirming with unspoken sentences, and it is impossible to say which is the greater agony: to be unfed or to be unheard. Isolated by their daily struggle for survival, the prisoners unite in the deeper solitude of sleep and the collective protest of their nightmares.

What *is* food, that it should be so fearsome and desirable? And why are all these hunger artists so desperate to resist its captivation? Food is the prototype of all exchanges with the other, be they verbal, financial, or erotic. Digestion is a kind of fleshly poetry, for metaphor begins in the body's transubstantiations of itself, while food is the thesaurus of all moods and all sensations. Its disintegration in the stomach, its assimilation in the blood, its diaphoresis in the epidermis, its metempsychosis in the large intestine; its viscosity in okra, gumbo, oysters; its elasticity in jellies; its deliquescence in blancmanges; its tumescence in the throats of serpents, its slow erosion in the bellies of sharks; its odysseys through pastures, orchards, wheat fields, stockyards, supermarkets, kitchens, pig troughs, rubbish dumps, disposals; the industries of sowing, hunting, cooking, milling, processing, and canning it; the wizardry of its mutations, ballooning in bread, subsiding in soufflés; raw and cooked, solid and melting, vegetable and mineral, fish, flesh, and fowl, encompassing the whole compendium of living substance: food is the symbol of the passage, the totem of sociality, the epitome of all creative and destructive labor.

Borges writes: "The world we live in is a mistake, a clumsy parody. Mirrors and fatherhood, because they multiply and confirm the

THE HUNGER ARTISTS

parody, are abominations. Revulsion is the cardinal virtue. Two ways (whose choice the prophet left free) may lead us there: abstinence or the orgy, excess of the flesh or its denial."[40] What Borges is implying here is that the fastest route to the end of man is through his stomach. Askesis and excess, the hunger strike and the *grande bouffe* only appear to be opposed, for both provide the lessons in revulsion that teach us to recoil from the grand fiasco of creation. Kafka once declared that the ascetic was the most insatiable of men; and by the same token, one could argue that the glutton was the most self-abnegating.[41] The one eats nothing, the other everything; but both are adventures in revulsion, and both defy the capacity of food, despite its infinite variety, to slake our thirst for lack, or to appease our everlasting hunger for the end. Clarissa says that she is "but a cipher," which suggests that she is hollow in the middle, and her starvation gives that emptiness its fleshly form (567). But there are many nuances of nothingness: and every hunger artist eats a different absence, speaks a different silence, and leaves a different kind of desolation.

Notes

Autophagy

1. Eve Sedgwick, "Labors of Embodiment," unpublished paper delivered at the MLA convention, 1987.

2. Stephen Dedalus describes Irish history as a "tale like any other too often heard" in the Nestor episode of James Joyce's *Ulysses* (1922; Harmondsworth: Penguin, 1986), p. 21.

3. See Susan Bordo, "Anorexia Nervosa: Psychopathology as the Crystallisation of Culture," in Irene Diamond and Lee Quinby, eds., *Feminism and Foucault: Reflections on Resistance* (Boston: Northeastern University Press, 1988), p. 90.

4. Joyce, *Ulysses,* p. 299.

5. Michel Foucault, *The History of Sexuality,* vol. 1 (New York: Vintage, 1980), p. 155; quoted in Bordo, "Anorexia Nervosa," p. 90.

6. See Stephen Greenblatt, *Renaissance Self-Fashioning: From More to Shakespeare* (Chicago: Chicago University Press, 1980), p. 179.

7. Roy Trakin, "Life in the Fasting Lane," *Details* (November 1989), p. 169.

8. See Caroline Bynum, *Holy Feast and Holy Fast: The Religious Significance of Food to Medieval Women* (Berkeley: University of California Press, 1987), p. 192.

9. Lukas Barr, "An Interview with Gayatri Chakravorty Spivak," *BLAST unLtd* (Summer 1989), p. 12.

10. Amartya Sen, *Poverty and Famines: An Essay on Entitlement and Deprivation* (Oxford: Clarendon Press, 1982), p. 8.

11. V. N. Voloshinov, *Marxism and the Philosophy of Language,* tr. Ladislav Matejka and I. R. Titunik (Cambridge, Mass.: Harvard University Press, 1986), pp. 87–9.

12. Theodor Adorno and Max Horkheimer, *Dialectic of Englightenment,* tr. J. Cumming (1944; reprint, New York: Seabury Press, 1972), p. 55.

13. Hillel Schwartz, *Never Satisfied: A Cultural History of Diets, Fantasies, and Fat* (New York: Macmillan, 1986).

14. See Schwartz, *Never Satisfied,* pp. 39, 17, 125, 126.

15. Quoted in Schwartz, *Never Satisfied,* p. 25.

16. Quoted in Schwartz, *Never Satisfied,* p. 38.

17. Schwartz, *Never Satisfied,* pp. 140–141.

18. Jean Anthelme Brillat-Savarin, *Physiologie du goût,* ed. Michel Ginbert, based on the first edition (Paris: A. Sautelet, 1826), p. 98.

19. The Standard Edition of *The Complete Psychological Works of Sigmund Freud,* tr. James Strachey (London: Hogarth, 1953–1974), vol. 12, p. 50. Henceforth cited as SE.

20. Schwartz, *Never Satisfied,* pp. 335–336.

21. Simone Weil, *Gravity and Grace* (London: Routledge, 1987), p. 18.

22. Jean Baudrillard, *America,* tr. Chris Turner (London: Verso, 1988), pp. 38–39.

23. If fat, for Americans, represents the stigma of the past, Thomas Mann associates it with deferral, with the *waste* of time. In *The Magic Mountain* (1924; tr. H. T. Lowe-Porter, New York: Vintage, 1969), he presents a world of pure consumption, in the economic, medical, and alimentary senses of the word, in which the world of labor is "forgotten" and only parasites remain, feeding on themselves in the absence of the lifeblood of production. In this auto-phagous economy, the body wastes away as fast as it can eat, devoured by the very sustenance of life: "They ate like wolves," Hans Castorp marvels (76). But the term "consumption" also implicates the narrative itself, and in particular the time "consumed in the telling" (183). The characters wait for death in the same way that the reader waits for the consummation of the plot, wasting time as gluttons waste their food. Indeed, time is so distended on the mountain that it loses any boundaries at all; and the damned who languish there devour their time like "a greedy man, whose digestive appa-

ratus works through quantities of food without converting it into anything of value or nourishment" (239). This consumptive body finds its counterpart in the elastic temporality of this fat book, swollen here, contracted there, and decomposing in the very process of its composition. In Mann, time represents the fat with which the novelist pads out the text, in the same way that life enlards the inexorable principle of entropy.

24. Edmund Spenser, "A Brief Note of Ireland," in *The Works of Edmund Spenser,* Vol. 9: *The Prose Works,* variorum ed. (Baltimore: Johns Hopkins University Press, 1949), p. 244.

25. Cecil Woodham-Smith, *The Great Hunger: Ireland 1845–1849* (1962; London: Hamish Hamilton, 1987), p. 22.

26. Freud, *Beyond the Pleasure Principle,* SE, vol. 18, pp. 12–23.

27. Andrée D. Sheehy Skeffington, ed., *Votes for Women: Irish Women's Struggle for the Vote,* (Dublin, n.d.), p. 23.

28. I am grateful to Luke Gibbons for suggesting these ideas to me in conversation and for drawing my attention to Hannah Sheehy Skeffington's memoir, cited above.

29. *Senchus Mor,* vol. 1 (Dublin: Alexander Thom; London: Longman, Green, Longman, Roberts, and Green, 1865), pp. 119, 113.

30. See David Beresford, *Ten Men Dead: The Story of the 1981 Irish Hunger Strike* (London: Grafton, 1987), pp. 14–15.

31. Fred Norris Robinson, "Notes on the Irish Practice of Fasting as a Means of Distraint," *Putnam Anniversary Volume* (Cedar Rapids, Iowa: Torch Press, 1909), pp. 570–571.

32. *Senchus Mor,* p. 119; See also Fergus Kelly, *A Guide to Early Irish Law,* Early Irish Law Series, vol. 3 (Dublin: Dublin Institute for Advanced Studies, 1988), pp. 182–183.

33. See Bynum, *Holy Feast and Holy Fast,* p. 6, where she argues that "medieval efforts to discipline and manipulate the body should be interpreted more as elaborate changes rung upon the *possibilities* provided by fleshliness than as flights from physicality."

34. J. M. Coetzee, *Life and Times of Michael K* (1983; Harmondsworth: Penguin, 1985).

35. The terms "quotation" and "afterlife" were suggested to me by Seamus Heaney in conversation.

36. Wole Soyinka, *The Man Died: Prison Notes* (1972; London: Arrow Books, 1985), p. 215.

37. See Rudolph M. Bell, *Holy Anorexia* (Chicago: University of Chicago Press, 1985), p. 20; and Bynum, *Holy Feast and Holy Fast,* pp. 194–207.

38. Hilde Bruch, *Conversations with Anorectics,* ed. Danita Czyzewski and Melanie A. Suhr (New York: Basic Books, 1988), p. 133. The tradition of fasting for a vision predates Christianity and reappears in many other faiths. It was common, for example, among native Americans: see "The Autobiography of a Winnebago Indian" and "Mountain Wolf Woman" in *The Portable North American Indian Reader,* ed. Frederick W. Turner III (Harmondsworth: Penguin, 1977), pp. 382–385, 455–457. For speculations on the relationship between hunger and hallucination in the Middle Ages, see Piero Camporesi, *Bread of Dreams: Food and Fantasy in Early Modern Europe,* tr. David Gentilcore (Chicago: University of Chicago Press, 1989), pp. 125–126. For a general discussion of fasting, dreams, visions, and revelations, see J. A. McCullough, "Fasting," *Encyclopedia of Religion and Ethics,* ed. James Hastings et al. (New York: Schribner's, 1908–1927), Vol.5, p. 762.

39. Victor V. Weizsacker, "Dreams in Endogenic *Magersucht,"*in *Evolution of Psychoanalytic Concepts: Anorexia Nervosa: A Paradigm,* ed. M. Ralph Kaufman et al (London: Hogarth Press, 1964), pp. 189–190.

40. I borrow this phrase from Cherry Boone O'Neill's autobiographical account of anorexia, *Starving for Attention* (New York: Dell, 1982).

41. See Salvator Minuchin, Bernice L. Rosman, and Lester Baker, *Psychosomatic Families: Anorexia Nervosa in Context* (Cambridge, Mass.: Harvard University Press, 1978), p. 11.

42. Victor Serge, *The Case of Comrade Tulayev,* tr. Willard R. Trask (Garden City, N.Y.: Doubleday, 1951), pp. 190–210.

43. Coetzee, *Life and Times of Michael K,* pp. 150–151, 199.

44. Seamus Heaney, "Station Island IX," in *Station Island* (New York: Farrar, Straus, and Giroux, 1989), p. 84.

45. Uri Eisenzweig, "Terrorism in Life and in Real Literature," *Diacritics,* 18, 3 (1988), pp. 34, 33.

46. See Padraig O'Malley, *Biting at the Grave: The Irish Hunger Strikes and the Politics of Despair* (Boston: Beacon Press, 1990), pp. 7, 57, 207.

47. David Beresford, "A Race Against Death," *The Guardian,* 29 April 1987, p. 9.

48. Jean Baudrillard, *In the Shadow of the Silent Majorities . . . Or, The End of the Social* (New York: Semiotext[e], 1983), pp. 48–58.

49. Greenwich time was established in 1882: this is perhaps the reason why the anarchists in Conrad's novel try to bomb the first meridian, for they

are laying siege to time itself, newly standardized with Greenwich as its epicenter, and by extension vandalizing the ideas of sequence, rhythm, and chronology. See Stephen Kern, *The Culture of Time and Space, 1880–1918* (Cambridge, Mass.: Harvard University Press, 1983), pp. 13, 16.

50. See Joseph Conrad, *The Secret Agent*, chap. 2, in *Tales of the East and West*, ed. Morton Dauwen Zabel (New York: Hanover House, 1958), pp. 371–372.

51. Liz Curtis has demonstrated, on the contrary, that the term *terrorism* functions as a crucial weapon in the propaganda war in Northern Ireland, for it is wielded much more frequently against the IRA than against their Protestant antagonists. In fact, it was to resist the *name* of terrorism and its stigma that the Long Kesh Hunger Strike was undertaken in the first place. See Liz Curtis, *Ireland: The Propaganda War* (London: Pluto Press, 1984).

52. Sheila MacLeod, *The Art of Starvation* (London: Virago, 1981).

53. See Stuart Schneiderman, *An Angel Passes: How the Sexes Became Undivided* (New York: New York University Press, 1988), p. 173.

54. Jackie Barrile, *Confessions of a Closet Eater* (1983), cited in Joan Brumberg, *Fasting Girls: The Emergence of Anorexia Nervosa as a Modern Disease* (Cambridge, Mass.: Harvard University Press, 1988), p. 282, n. 25.

55. Brumberg, *Fasting Girls*, p. 20.

56. Brumberg, *Fasting Girls*, p. 19.

57. Bruch, *Conversations with Anorectics*, p. 4.

58. Susie Orbach, *Hunger Strike* (London: Faber, 1986).

59. See, inter alia, "The Peter Pan Syndrome: Was James M. Barrie Anorexic?" *International Journal of Eating Disorders*, 8, 3 (1989), pp. 369–376; Manfred M. Fichter, "The Anorexia Nervosa of Franz Kafka," *International Journal of Eating Disorders*, 6, 3 (1987), pp. 367–377; "Goethe's Ottilie: An Early 19th Century Description of Anorexia Nervosa," *Journal of the Royal Society of Medicine*, 83 (1990), pp. 581–585; Heather Kirk Thomas, "Emily Dickinson's 'Renunciation' and Anorexia Nervosa," *American Literature*, 60, 2 (1988), pp. 205–225.

60. See Sandra Gilbert and Susan Gubar, *The Madwoman in the Attic: The Woman Writer and the Nineteenth Century Imagination* (New Haven: Yale University Press, 1979), pp. xi, 25, 53–59.

61. See Helena Michie, *The Flesh Made Word: Female Figures and Women's Bodies* (Oxford: Oxford University Press, 1987), pp. 12ff.

62. See *The Letters of George Cheyne to Samuel Richardson, 1733–1743*, ed. Charles F. Mullett (Columbia: University of Missouri Press, 1943), p. 69; and

T. C. Duncan Eaves and Ben K. Kimpel, *Samuel Richardson: A Biography* (Oxford: Oxford University Press, 1971), p. 63.

63. Wilma Paterson, "Was Byron Anorexic?" *World Medicine,* 17 (15 May 1982), pp. 35–38.

64. James B. Twitchell, *The Living Dead: A Study of the Vampire in Romantic Literature* (Durham, N.C.: Duke University Press, 1981), p. 142.

65. Michel Serres, *The Parasite,* tr. Lawrence R. Scher (Baltimore: Johns Hopkins University Press, 1982), p. 131.

66. James Joyce, *Finnegans Wake* (1939; New York: Viking Press, 1967), p. 186.

67. See André Gide, *So Be It; or, The Chips Are Down,* tr. Justin O'Brien (New York: Knopf, 1959), p. 5: "I have made the acquaintance of a word that describes a condition from which I have been suffering for months—a very beautiful word: anorexia . . . " See also p. 8.

68. Knut Hamsun, *Hunger,* tr. Robert Bly (New York: Farrar, Straus, and Giroux, 1986), pp. 36, 33.

69. Aldous Huxley, "The Farcical History of Richard Greenow," in *Limbo* (New York: Doran, 1920).

70. W. B. Yeats, *Collected Poems* (New York: Macmillan, 1956), p. 159.

71. W. B. Yeats, *Per Amica Silentia Lunae,* in *Mythologies* (New York: Collier, 1969), p. 341.

72. See, for instance, Keats's "To Fanny":

> Physician Nature! Let my spirit blood
> O ease my heart of verse and let me rest;
> Throw me upon thy tripod till the flood
> Of stifling numbers ebbs from my full breast.

Gynophagy

1. As Bachelard puts it, "L'enfant porte à la bouche les objets avant de les connaître, pour les connaître." For the infant, "*Le réel est de prime abord un aliment.*" See "Le Mythe de la Digestion," in *La Formation de l'esprit scientifique: Contribution à une psychanalyse de la connaissance objective,* 11th ed. (Paris: Librarie Philosophique J. Vrin, 1980), p. 169.

2. Marx W. Wartovsky, *Feuerbach* (Cambridge: Cambridge University Press, 1977), p. 414.

3. Letter to Richard Woodhouse, 21–22 September 1819, in *Letters of*

John Keats, ed. Robert Gittings (Oxford: Oxford University Press, 1975), p. 293.

4. Hegel, *Phenomenology of Spirit,* tr. A. V. Miller (Oxford: Oxford University Press, 1977), p. 65.

5. All the quotations above come from Hegel, *Aesthetics,* ed. Knox, Vol. I, p. 36.

6. Karl Marx, "Critique of the Hegelian Dialectic and Philosophy as a Whole," in *The Economic and Philosophical Manuscripts of 1844,* ed. Dirk J. Struick, tr. Martin Milligan (New York: International Publishers, 1973), pp. 179–181.

7. This pun predates Feuerbach, however, as Wartovsky explains in *Feuerbach,* p. 413.

8. Sylvia Pankhurst, *The Suffragette Movement: An Intimate Account of Persons and Ideals* (1931), intro. Richard Pankhurst (London: Virago, 1977), pp. 443–444.

9. Pankhurst, *The Suffragette Movement,* pp. 444–447.

10. Djuna Barnes, "How it Feels to be Forcibly Fed," *New York World Magazine* (6 September 1914), reprinted in *New York,* ed. Alyce Barry (London: Virago, 1990), pp. 175, 179.

11. Constance Lytton, *Prisons and Prisoners: The Stirring Testimony of a Suffragette* (1914), intro. Midge Mackenzie (London: Virago, 1988), p. 270.

12. See Jean Laplanche, *Life and Death in Psychoanalysis,* tr. Jeffrey Mehlman (Baltimore: Johns Hopkins University Press, 1976), pp. 15–20.

13. Melanie Klein, *Love, Guilt, and Reparation and Other Works 1921–1945,* intro. R. E. Money-Kyrle (New York: Delta, 1977), p. 290.

14. Laplanche, *Life and Death in Psychoanalysis,* pp. 23–24.

15. As Bachelard observes, "La digestion correspond en effet à une prise de possession d'une évidence sans pareille, d'une sureté inattaquable" ("Le Mythe de la Digestion," p. 169).

16. Julia Kristeva, *Powers of Horror: An Essay on Abjection,* tr. Leon S. Roudiez (New York: Columbia University Press, 1982), p. 3.

17. *Group Psychology* (1921), SE, vol. 18, p. 105.

18. Freud, *Group Psychology,* SE, vol. 18, p. 105.

19. Klein, "Mourning and its Relation to Manic-Depressive States" (1940), in *Love, Guilt and Reparation,* pp. 346, 345.

20. Klein, *Love, Guilt and Reparation,* p. 364.

21. Nicolas Abraham and Maria Torok, *The Wolf Man's Magic Word: A Cryptonomy,* tr. Nicholas Rand (Minneapolis: University of Minnesota Press, 1986).

22. Cited in Salvator Minuchin, Bernice L. Rosman, and Lester Baker, *Psychosomatic Families: Anorexia Nervosa in Context* (Cambridge, Mass.: Harvard University Press, 1978), p. 14.

23. Karl Abraham, "A Short Study of the Development of the Libido," *Selected Papers* (London: Hogarth, 1927), p. 418. See also Klein, "A Contribution to the Psychogenesis of Manic-Depressive States" (1935), in *Love, Guilt and Reparation,* p. 269.

24. Leo Bersani speaks of the "moribund nature of the ego" in Freud, its "status as a kind of cemetery of decathected object-choices" in *The Freudian Body: Psychoanalysis and Art* (New York: Columbia University Press, 1986), pp. 93–100.

25. See McCullough, "Fasting," *Encyclopedia of Religion and Ethics,* ed. James Hastings et al. (New York: Schribner's, 1908–1927), vol. 5, p. 760.

26. Freud, "On Transformations of Instinct as Exemplified in Anal Erotism" (1917), SE, vol. 17, pp. 130, 128. Castration fantasies reveal that the penis is also regarded as detachable and therefore as analogous to all the other currencies in this unconscious commerce.

27. Waller, Kaufman, and Deutsch argue that anorexia implies the "wish to be impregnated through the mouth which results, at times, in compulsive eating, and at other times, in guilt and consequent rejection of food." Even the amenorrhea mimes the state of pregnancy, in which menstruation also ceases for a time, although this symptom "may also be part of the direct denial of genital sexuality." See John V. Waller, M. Ralph Kaufman, and Felix Deutsch, "Anorexia Nervosa: A Psychosomatic Entity" (1940), in M. Ralph Kaufman et al., eds., *Evolution of Psychosomatic Concepts: Anorexia Nervosa: A Paradigm* (London: Hogarth Press, 1964), p. 272.

28. E. I. Falstein, S. E. Feinstein, and I. Judas, "Anorexia Nervosa in the Male Child," *American Journal of Orthopsychiatry,* 26 (1956), pp. 751–772; quoted in Minuchin et al., *Psychosomatic Families,* p. 15.

29. Susie Orbach writes, "She thinks about how much she has eaten, how she will avoid eating for the next few days and how much better she will feel once she has constructed a plan. In other words, she is diverted into her obsession where things work out all right" (*Hunger Strike,* London: Faber, 1986, p. 115).

30. Cited in Rudolph M. Bell, *Holy Anorexia* (Chicago: University of Chicago Press, 1985), p. 16.

31. Margaret Atwood, *The Edible Woman* (1969; London: Virago, 1980), p. 115.

32. Klein, *Love, Guilt and Reparation,* p. 33.

33. Lewis Hyde, *The Gift: Imagination and the Erotic Life of Property* (New York: Vintage, 1983), p. 10.

34. Salman Rushdie, "Is Nothing Sacred?" The Herbert Read Memorial lecture, 9 February 1990 (Granta: First U.S. Edition, 1990), p. 2.

35. See Stuart Schneiderman, *An Angel Passes: How the Sexes Became Undivided* (New York: New York University Press, 1988), p. 173.

36. Gilles Deleuze and Félix Guattari, *Kafka: Toward a Minor Literature,* tr. Dana Polan (Minneapolis: University of Minnesota Press, 1986), p. 20.

37. Woolf, *Between the Acts* (1941; Harmondsworth: Penguin, 1973), p. 11.

38. Deleuze and Guattari have argued that "writing goes further than speech in transforming words into things capable of competing with food" (*Kafka,* p. 20).

39. Ella Freeman Sharpe, "Psycho-Physical Problems Revealed in Language: An Examination of Metaphor" (1940), in *Collected Papers on Psycho-Analysis,* ed. Marjorie Brierley (London: Hogarth Press, 1978), pp. 157, 162, 163.

40. Schneiderman, *An Angel Passes,* p. 171.

41. Quoted by Alison Glenny, *Ravenous Identity: The Influence of Anorexic Patterns of Thinking on the Treatment of Food in Virginia Woolf's Fiction,* Unpub. PhD. Dissertation, University of London, 1990, p. 41.

42. Schneiderman, *An Angel Passes,* p. 171.

43. Victoria Shahly, "Eating Her Words: Food Metaphor as Transitional Symptom in the Recovery of a Bulimic Patient," in *The Psychoanalytic Study of the Child,* vol. 42 (1987), pp. 408–421.

44. Mary Gordon, *Final Payments* (1978; New York: Ballantine Books, 1979). Page numbers in text refer to this edition.

45. Cherry Boone O'Neill, *Starving for Attention,* (New York: Dell, 1982), p. 12.

46. See Shahly, "Eating Her Words," p. 408.

47. Michel Serres, *The Parasite,* tr. Lawrence R. Scher (Baltimore: Johns Hopkins University Press, 1982), p. 106.

48. See Jacques Lacan, *The Four Fundamental Concepts of Psychoanalysis,* ed. Jacques-Alain Miller, tr. Alan Sheridan (London: Hogarth, 1977), p. 104. See also Ellie Ragland-Sullivan, *Jacques Lacan and the Philosophy of Psychoanalysis* (Urbana: University of Illinois Press, 1986), p. 73.

49. Orbach, *Hunger Strike,* pp. 99–101.

50. See, inter alia, "Psycho-Analysis and Telepathy," SE, vol. 18, pp. 173–

193; and "Dreams and Telepathy," SE, vol. 18, pp. 195–220. See also Jacques Derrida, "Telepathy," *Oxford Literary Review,* 10 (1988), pp. 3–41; and Nicholas Royle, *Telepathy and Literature: Essays on the Reading Mind* (Oxford: Blackwell, 1991).

51. James Joyce, *Ulysses* (Harmondsworth: Penguin, 1986), p. 32.

52. Bram Stoker, *Dracula* (1897; Oxford: Oxford University Press, 1983). Page numbers in text refer to this edition.

53. See Derrida's discussion of the "dangerous supplement" in Rousseau in *Of Grammatology,* tr. Gayatri Chakravorty Spivak (Baltimore: Johns Hopkins University Press, 1976), pp. 141–164.

54. Serres, *The Parasite,* p. 86.

Sarcophagy

1. W. B. Yeats, *The King's Threshold,* in *Collected Plays* (London: Macmillan, 1982), p. 108. Page numbers in text refer to this edition.

2. Yeats, note appended to revised version of *The King's Threshold* in *Plays in Prose and Verse Written for an Irish Theatre* (London, 1922), p. 243. For an account of the chronology of revisions, see John Rees Moore, *Masks of Love and Death: Yeats as Dramatist* (Ithaca, New York: Cornell University Press, 1971), p. 423.

3. David Beresford, *Ten Men Dead: The Story of the 1981 Irish Hunger Strike* (London: Grafton, 1987), p. 19. Terence MacSwiney developed this philosophy from the *Imitation of Christ* of Thomas à Kempis, which he read tirelessly with his sister Mary during his last days on hunger strike. See Charlotte H. Fallon, *Soul of Fire: A Biography of Mary MacSwiney* (Cork and Dublin: Mercier Press, 1986), pp. 46, 51.

4. The final version was first printed in *Plays in Prose and Verse Written for an Irish Theatre;* and Yeats, in his note on p. 243, explains that he gave the play "the tragic end I would have given it at the first, had not a friend advised me to 'write comedy and have a few happy moments in the theatre.'"

5. Yeats may have borrowed this idea from the pseudonymous Aristotle's *Masterpiece* (1694), apparently the most widely circulated work of pseudosexual and pseudomedical folklore in seventeenth- and eighteenth-century England.

6. W. B. Yeats, *Collected Poems,* (New York: Macmillan, 1956), p. 191.

7. See Yeats, "Among School Children" and "The Gift of Harun Al-Rashid," in *Collected Poems,* pp. 213, 444.

8. Yeats, *Collected Poems*, pp. 157–158.

9. Yeats, *Per Amica Silentia Lunae*, in *Mythologies* (New York: Collier, 1969), pp. 341, 337, 329, 332.

10. CH'U YU II, 2; quoted in René Girard, *Violence and the Sacred*, tr. Patrick Gregory (Baltimore: Johns Hopkins University Press, 1986), p. 8.

11. Girard, p. 39.

12. Franz Kafka, "A Hunger Artist" (1922), in *The Complete Stories*, ed. Nahum N. Glatzer (New York: Schocken Books, 1983). Page numbers in text refer to this edition.

13. Quoted from Kafka's *Diaries* of 1921 by Gilles Deleuze and Félix Guattari in *Kafka: Toward a Minor Literature*, tr. Dana Polan (Minneapolis: University of Minnesota Press, 1986), p. 22.

14. See Breon Mitchell, "Kafka and the Hunger Artists," in *Kafka and the Contemporary Critical Performance*, ed. Alan Udoff (Bloomington: Indiana University Press, 1987), pp. 236–255.

15. See Jean Jofen, *The Jewish Mystic in Kafka* (New York: Peter Lang, 1987), p. 101. Patrick Mahoney has pointed out that an "ironical reversal" takes place in "A Hunger Artist," whereby the forty days conclude rather than commence with a parody of baptism. See Mahoney, "Kafka's 'A Hunger Artist' and the Symbolic Nuclear Principle," in *Psychoanalysis and Discourse* (London: Tavistock, 1987), p. 198.

16. See Mahoney, *Psychoanalysis and Discourse*, p. 208, n. 17.

17. In *Totem and Taboo* (1912–1913), Freud argues that the sacrificial rituals of primitive religions have survived in the form of the obsessive ceremonials of civilized neurotics; and in a similar way, Kafka suggests that fasting has been transformed from a public ritual into a private compulsion. When the hero finally admits that he is not an artist but an anorectic who could never find a food he liked to eat, the social economics of his sacrifice have been effaced.

18. Theodor Adorno and Max Horkheimer, *Dialectic of Enlightenment*, tr. J. Cumming (1944; reprint, New York: Seabury Press, 1972), p. 55.

19. Deleuze and Guattari, *Kafka*, p. 20.

20. This is how De Quincey uses the word, for instance, in his story "Mr. Schnackenburger; or, Two Masters for One Dog" (1823) in which a man afflicted with a canine appetite is accused of eating children. "There was a case of boulimia at Thoulouse," he writes, "where the French surgeons caught the patient and saturated him with opium; but it was of no use; for he ate as many children after it as before." Though the patient denies the

charge—"'Pon my honour,' he sometimes said, 'between ourselves, I never *do* eat children'"—there is no doubt that he must be "paedophagous or infantivorous," for "certain it is that, wherever he appeared, a sudden scarcity of children prevailed." *The Collected Writings of Thomas De Quincey,* ed. David Masson (Edinburgh: A. N. C. Black, 1890), vol. 12, pp. 356, 357n.

21. Stuart Schneiderman, *An Angel Passes: How the Sexes Became Undivided* (New York: New York University Press, 1988), p. 171.

22. See Jochen Schulte-Sasse, Foreword to Peter Bürger, *Theory of the Avant-Garde,* tr. Michael Shaw (Minneapolis: University of Minnesota Press, 1984), p. ix.

23. Kafka's investigating dog literally gnaws at his own buttocks and mistakes the blood that he has retched out of his empty maw for food.

24. Ciaran Nugent, in 1976, was the first prisoner to refuse to wear the prison uniform; see Patrick Bishop and Eamonn Mallie, *The Provisional IRA* (London: Heinemann, 1987), pp. 349–350. See also Tim Pat Coogan, *On the Blanket: The H-Block Story* (Dublin: Ward River Press, 1980).

25. Gerry Adams explains how the dirty protest was initiated by prison warders, mostly loyalists, who emptied chamber pots on prisoners' beds: see Adams, *The Politics of Irish Freedom* (Dingle: Brandon Books, 1986), p. 74.

26. Cecil Woodham-Smith, *The Great Hunger: Ireland, 1845–49* (1962; London: Hamish Hamilton, 1987), p. 16.

27. John Berger, *Ways of Seeing* (London: British Broadcasting Corporation and Penguin, 1972), p. 47.

28. The five demands were: (1) the right to wear their own clothes; (2) the right not to do prison work; (3) the right to freely associate with fellow prisoners; (4) the right to full fifty percent remission of their sentences; and (5) access to normal visits, parcels, education, and recreational facilities. See Tim Pat Coogan, *The IRA* (1970; rev. ed., Glasgow: Fontana/Collins, 1987), p. 616.

29. See Liz Curtis, *Ireland: The Propaganda War* (London: Pluto Press, 1984).

30. Page references are to Samuel Richardson, *Clarissa, or the History of a Young Lady* (1747–1748), ed. Angus Ross (Harmondsworth: Penguin, 1985).

31. Terry Castle, *Clarissa's Ciphers: Meaning and Disruption in Richardson's Clarissa* (Ithaca, N.Y.: Cornell University Press, 1982), p. 38.

32. See Judith Wilt, "He Could Go No Farther: A Modest Proposal about Lovelace and Clarissa," *Proceedings of the Modern Language Association,* 92 (1977), p. 19.

33. Jacques Lacan, seminar on "The Purloined Letter," *Yale French Studies,* 48 (1972), p. 57.

34. See Jacques Derrida, *The Post Card,* tr. Alan Bass (Chicago: University of Chicago Press, 1987), p. 39: "The name is made to do without the life of the bearer, and is therefore always somewhat the name of someone dead."

35. For a brilliant analysis of this kind of triangular structure of desire, see Eve Kosofsky Sedgwick, *Between Men: English Literature and Male Homosocial Desire* (New York: Columbia University Press, 1985), *passim.*

36. Yet even Clarissa acknowledges that writing is compulsive and libidinous. If Lovelace says, "I must write on, and cannot help it" (721), Clarissa echoes him: "I *must* write on" (904). See Terry Eagleton, *The Rape of Clarissa* (Minneapolis: University of Minnesota Press, 1982), p. 42.

37. David Herlihy, "The Making of the Medieval Family: Symmetry, Structure and Sentiment," *Journal of Family History,* 8, 2 (1983), p. 116; cited in Caroline Bynum, *Holy Feast and Holy Fast: The Religious Significance of Food to Medieval Women* (Berkeley: University of California Press, 1987), p. 223.

38. The Catholic hierarchy in England, personified by Cardinal Hume, insisted that the hunger strike deaths were suicides. See Beresford, *Ten Men Dead,* p. 342.

39. See Petr Skrabanek, "Notes Towards the History of Anorexia Nervosa," *Janus: Revue internationale de l'histoire des sciences, de la médicine et de la technique,* 70 (1983), pp. 109–128.

40. In fact, it is Lovelace's own letters that Clarissa arrays against him in retaliation. She writes to Anna Howe: "I had begun the particulars of my tragical story: but it is so painful a task . . . that could I avoid it, I would go no farther in it . . . Mr. Lovelace, it seems, has communicated to his friend Mr. Belford all that has passed between himself and me . . . and therefore the particulars of my story, and the base arts of this vile man will, I think, be best collected from those very letters of his" (1163).

41. See Beresford, *Ten Men Dead,* p. 30.

42. Derrida, *The Post Card,* p. 29.

43. The prisoners, however, never openly acknowledge the homoerotism of this interchange (at least in Beresford's account), as if this idea were too dangerous even to be grist for ribaldry. Eve Sedgwick, in *Between Men,* has pointed out that the homo*social* bonds of patriarchy depend on the repression of their homo*sexual* component, resulting in the vicious persecution of gay men; whereas the bonds of erotism between women coexist more peacefully with their platonic bonds of common interest. It is instructive, therefore, to

contrast the prisoners' self-censorship to another epistolary text in which the theme of love is closely linked to that of letters, but in which the lovers are black women rather than white men. This is Alice Walker's *The Color Purple* (New York: Harcourt Brace Jovanovich, 1983), which tells the story of Celie's lesbian affair with Shug and of her liberation from her sexual and vocal subjugation. Shug initiates Celie into "finger-and-tongue work": that is, she encourages her to use her fingers and her tongue to write, to speak, and to make love, in a cunnilinguistics that encompasses both word and flesh.

44. Eagleton, *The Rape of Clarissa,* p. 54.

45. Beresford, *Ten Men Dead,* pp. 30, 85, 75, 72, 73.

46. The inmates came to dread their visitors, because the mirror search inevitably followed, accompanied by unusually brutal beatings: see Coogan, *On the Blanket,* pp. 9–10.

47. During the dirty protest, the prisoners became afraid of catching sight of their own images in mirrors; yet the photographs they smuggled out of Long Kesh actually served to reinforce their cause. Standing solemn and defiant in their filthy cells, with blankets draped around their naked shoulders, their bearded, lank-haired faces brought to mind the images of Christ that decorate the houses of the Catholic working class. See Bishop and Mallie, *The Provisional IRA,* p. 280.

48. Beresford, *Ten Men Dead,* p. 71.

49. Elaine Scarry, *The Body in Pain: The Making and Unmaking of the World* (Oxford: Oxford University Press, 1985), p. 56.

50. Beresford, *Ten Men Dead,* p. 60.

51. Cited by Padraig O'Malley in *Biting at the Grave: The Irish Hunger Strikes and the Politics of Despair* (Boston: Beacon Press, 1990), p. 55.

52. Beresford, *Ten Men Dead,* p. 88.

53. Beresford, *Ten Men Dead,* pp. 60, 88.

54. This system resembles the illicit mail in Thomas Pynchon's novel, *The Crying of Lot 49* (1965; London: Picador, 1979). Here letters are deposited in waste baskets (much as the comms of Long Kesh were posted in the place of excrement), and their purpose is primarily to reaffirm the system of exchange itself. For this reason it is crucial that they circulate continuously even if they are devoid of content. As one of the characters explains, "To keep it up to some kind of a reasonable volume, each member has to send at lest one letter a week through the [W.A.S.T.E.] system. If you don't, you get fined." As a result, the members find themselves exchanging such absurdly phatic messages as the following: *"Dear Mike,* [the letter] said, *How are you?*

Just thought I'd drop you a note" (35). There is no information here to be conveyed, but the point of such communications is to name the other members of the system and to embrace them in its postal tentacles. Those of us in education are undoubtedly familiar with a similarly small and fecal form of correspondence whose purpose is invocatory rather than informative. These are departmental memos, which circulate continuously, at the cost of an enormous daily waste of paper. Their purpose is primarily to summon colleagues from their rest, their dissipations, or even their research, for the content of the messages is generally nugatory.

55. Beresford, *Ten Men Dead,* p. 134.

56. Beresford, *Ten Men Dead,* pp. 134, 55.

57. For the concept of the "struggle for the sign," see V. N. Voloshinov, *Marxism and the Philosophy of Language,* tr. Ladislav Matejka and I. R. Titunik (Cambridge, Mass.: Harvard University Press, 1986), pp. 23–24.

58. Maze is the name of a neighboring village.

59. T. S. Eliot uses this definition as the epigraph to *Notes towards the Definition of Culture* (London: Faber, 1948).

60. Bachelard, *The Poetics of Space* (1958), tr. Maria Jolas (Boston: Beacon Press, 1969), p. 222.

Encryptment

1. Emily Brontë, *Wuthering Heights* (1847; London: Corgi Books, 1974), chap. 9, p. 79; see also chap. 7. The primary significance of "starving" in this context is "freezing," a meaning I explore later in the chapter.

2. See Padraig O'Malley, *Biting at the Grave: The Irish Hunger Strikes and the Politics of Despair* (Boston: Beacon Press, 1990), p. 53.

3. Cited by Terry Eagleton, *The Rape of Clarissa* (Minneapolis: University of Minnesota Press, 1982), p. 47. Note that Clarissa describes her own body as "nothing" (1421).

4. Franz Kafka, *Letters to Felice,* tr. James Stern and Elizabeth Duckworth, ed. Erich Heller and Jurgen Born (London: Martin Secker and Warburg, 1974), pp. 155–156.

5. Jacques Derrida, "Fors," Preface to Nicolas Abraham and Maria Torok, *The Wolf Man's Magic Word: A Cryptonomy,* tr. Nicholas Rand (Minneapolis: University of Minnesota Press, 1986), p. xvii.

6. David Beresford, *Ten Men Dead: The Story of the 1981 Irish Hunger Strike* (London: Grafton, 1987), pp. 126–127. It is symptomatic of the interplay of food and words that McFarlane puns on Kipling's poetry and Kipling's cakes,

making an edible text, or a readable feast. His own name, Bik, was shortened from McFarlane's biscuits.

7. Freud, *The Interpretation of Dreams,* SE, vol. 5, p. 525.

8. In this sense Lovelace provides a textbook example of the Kleinian theory that the infant dreams of gouging out the contents of the mother's body to raid the treasures hidden in her flesh. His fantasies also compare to the ritual dismemberment of saints, such as Saint Teresa, whose limbs were torn from her corpse in a wild rush to acquire sacred relics of her fragrant and mysteriously uncorrupted flesh. See *The Life of Saint Teresa of Avila by Herself,* tr. and intro. J. M. Cohen (Harmondsworth: Penguin, 1958), p. 16.

9. Ruth Perry, *Women, Letters, and the Novel* (New York: AMS Press, 1980), p. 107. Perry contends that the scene of a character shut up alone in a room with some paper and a pen is specifically a "middle class image" (p. 33).

10. Perry, *Women, Letters, and the Novel,* pp. 33, 107.

11. Michel Foucault, *The History of Sexuality,* vol. 1: *An Introduction* (New York: Vintage, 1980). pp. 92–102.

12. Elaine Scarry, *The Body in Pain: The Making and Unmaking of the World* (New York: Oxford University Press, 1985), p. 40.

13. Donne, "The Good Morrow."

14. Compare Bachelard, *The Poetics of Space* (1958), tr. Maria Jolas (Boston: Beacon Press, 1969), p. 230, who writes, "Isn't the exterior an old intimacy . . . ?"

15. Scarry, *The Body in Pain,* p. 40.

16. Walter Benjamin, *Charles Baudelaire: A Lyric Poet in the Era of High Captialism,* tr. Harry Zohn (London: Verso, 1983), p. 169.

17. Quoted in Liz Curtis, *Ireland: The Propaganda War* (London: Pluto Press, 1984), pp. 31–32.

18. Bachelard, *The Poetics of Space,* p. 222.

19. Curtis, *Ireland: The Propaganda War,* p. 32.

20. Scarry, *The Body in Pain,* pp. 28–29.

21. Beresford, *Ten Men Dead,* p. 52. See also the pamphlet *Strip Searching,* an inquiry into the strip searching of women remand prisoners at Armagh prison between 1982 and 1985 (London: National Council for Civil Liberties, 1986).

22. Naomi Wolf, *The Beauty Myth* (London: Chatto and Windus, 1990), p. 113.

23. *Paradise Lost,* Book 2, line 600. See also note 1 above.

24. Jacques Lacan, *The Four Fundamental Concepts of Psychoanalysis,* ed. Jacques-Alain Miller, tr. Alan Sheridan (London: Hogarth, 1977), p. 93. See also Michel Foucault, "The Eye of Power," in *Power / Knowledge,* ed. Colin Gordon (Brighton: Harvester, 1980), pp. 146–165.

25. Gwendolyn Brooks speaks of the "gobbling mother-eye" in her poem about abortion, "The Mother."

26. Beresford, *Ten Men Dead,* p. 275.

27. See Beresford, *Ten Men Dead,* p. 130.

28. Margaret Atwood, *The Edible Woman* (1969; London: Virago, 1980), pp. 167, 196.

29. Wole Soyinka, *The Man Died: Prison Notes* (1972; London: Arrow Books, 1985), p. 216.

30. Soyinka, *The Man Died,* pp. 223–228.

31. Pankhurst, *The Suffragette Movement,* p. 445.

32. Soyinka, *The Man Died,* p. 215.

33. J. M. Coetzee, *Life and Times of Michael K* (1983; Harmondsworth: Penguin, 1985), p. 223. Further references included in text.

34. Michel Serres, *The Parasite,* tr. Lawrence R. Scher (Baltimore: Johns Hopkins University Press, 1982), p. 87.

35. Victor Serge, *The Case of Comrade Tulayev,* tr. Willard R. Trask (Garden City, N.Y.: Doubleday, 1951), p. 196.

36. Soyinka, *The Man Died,* pp. 228, 229.

37. W. B. Yeats, "His Confidence," *Collected Poems* (New York: Macmillan, 1956), p. 257.

38. Lewis Hyde, *The Gift: Imagination and the Erotic Life of Property* (New York: Vintage, 1983), p. 23.

39. Primo Levi, *If This Is a Man* (1958), in *If This Is a Man* and *The Truce,* tr. Stuart Wolf (London: Sphere Books, 1987), pp. 66–67.

40. J. L. Borges, *A Universal History of Infamy* (Harmondsworth: Penguin, 1973), p. 83.

41. Kafka, "A Hunger-Strike," in *Parables and Paradoxes* (New York: Schocken Books, 1970), p. 31.

Index

pared to *Clarissa*, 16, 71–73, 81, 83–85, 88, 91, 95, 104, 107; compared to terrorism, 19–20; protest against "criminalization," 70–71; the prisoners' "five demands," 72, 126n28. *See also* Long Kesh prison

James, Henry, 8
Jofen, Jean, 125n15
Joyce, James: *Finnegans Wake*, 26; *Ulysses*, 3, 4, 55
Judas, I., 122n28

Kafka, Franz, 69–70, 93–94, 119n59; "The Burrow," 69, 93–94; "The Great Wall of China," 94; "A Hunger Artist," 17, 59, 65–67, 69, 93–94, 125n14; "A Hunger-Strike," 113; "Investigations of a Dog," 68–70, 93, 126n23; "The Metamorphosis," 67–68, 93; "The Penal Colony," 4, 69
Kaufman, M. Ralph, 122n27
Keats, John, 27, 30, 120n72
Kelly, Fergus, 117n32
Kern, Stephen, 119n49
Kierkegaard, Søren, 29
Kimpel, Ben K., 120n62
Kitchener, William, 8
Klein, Melanie, 38, 40–41, 42, 43, 95, 130n8
Kristeva, Julia, 40

Lacan, Jacques, 27, 42, 51, 53, 77, 104
Laplanche, Jean, 37, 38–39
Levi, Primo: *If This Is a Man*, 111–112
Long Kesh prison (now known as the Maze), 16, 21, 70–71, 72, 73, 83, 84, 85, 88, 93, 99–100, 101–102, 105–106, 128nn46,47; protests in, 70–71, 72–73, 126nn24,25; illicit postal system in, 83–88, 104–105, 107, 108, 128–129n54; name changed to the Maze, 88, 129n58; psychodynamics of

imprisonment in, 91–93, 99–101, 105–106, 107
Lytton, Constance, 35

MacSwiney, Mary, 124n3
MacSwiney, Terence, 60, 124n3
Mahoney, Patrick, 125n15
Mallie, Eamonn, 126n24
Mann, Thomas: *The Magic Mountain*, 116–117n23
Marcuse, Herbert, 4
Marx, Karl, 30, 32–33
Maze prison. *See* Long Kesh prison
McCullough, J. A., 118n38, 122n25
McFarlane, Bik, 84, 87, 96, 129–130n6
McLeod, Sheila, 21
McLuhan, Marshall, 24
Michie, Helena, 24
Milton, John, 102
Minuchin, Salvator, 43, 118n41
Mitchell, Breon, 125n14
Moore, John Rees, 124n2
Morton, Richard, 17, 82

Nightingale, Florence, 1
Nugent, Ciaran, 126n24

O'Malley, Padraig, 118n46, 129n2
O'Neill, Cherry Boone, 50–51, 118n40
Orbach, Susie, 22, 24, 54, 122n29

Pankhurst, Sylvia: *The Suffragette Movement*, 33–35, 101, 107
Paterson, Wilma, 120n63
Perry, Ruth, 98, 130n9
Plath, Sylvia, 25
Poe, Edgar Allan, 41
Pynchon, Thomas: *The Crying of Lot 49*, 128–129n54

Ragland-Sullivan, Ellie, 123n48
Rees, Merlyn, 88
Revelation, Book of, 22
Richardson, Samuel, 25; *Clarissa*, 25, 60, 70–84, 85, 88, 91, 92, 95–99, 100,

INDEX